ABANDONED
EAST BAY
SAN FRANCISCO
WHERE GRAFFITI IS KING

XAN BLOOD WALKER

AMERICA
THROUGH TIME®
ADDING COLOR TO AMERICAN HISTORY

America Through Time is an imprint of Fonthill Media LLC
www.through-time.com
office@through-time.com

Published by Arcadia Publishing by arrangement with Fonthill Media LLC
For all general information, please contact Arcadia Publishing:
Telephone: 843-853-2070
Fax: 843-853-0044
E-mail: sales@arcadiapublishing.com
For customer service and orders:
Toll-Free 1-888-313-2665

www.arcadiapublishing.com

First published 2020

ISBN 978-1-63499-271-8

Typeset in Trade Gothic
Printed and bound in England

CONTENTS

Acknowledgments **4**

Introduction **5**

1 Graffiti **7**

2 The East Bay **9**

3 Oakland **11**

4 Berkeley **38**

5 Emeryville **48**

6 Albany **62**

7 Alameda **73**

8 Richmond **80**

Glossary **92**

Bibliography **93**

About the Author **95**

ACKNOWLEDGMENTS

FIRST, I want to thank my heart, my son, Marlon Walker; for keeping me grounded, helping me be a better version of myself, and teaching me about unconditional love. He's awesome, he doesn't even know. I also want to thank my biggest supporter, my mom, Barbara Blood-Walker. She is the rock of the family who never gave up on me and has always encouraged and supported me. Thanks, Mom.

I also want to thank other family and friends who support me in my creative efforts. You don't know how far just a little encouragement goes. It is all noted and appreciated. I'm not as strong as people sometimes think I am.

I'd be remiss if I also didn't thank my day job for giving me the financial stability to be able to pursue my art on my terms.

I want to thank the publishing team at Fonthill Media, without whom this book wouldn't have been made possible, with a special shout out to Jay Slater, who reached out to me and took a chance on me. What a delightful surprise when I first got his email. Sometimes as an artist I feel invisible, and it was nice to know that I was seen.

I want to thank all the graffiti artists and taggers that make our world more colorful in some of the most surprising and creative ways. Keep on rockin'. I'm sorry I can't give most of you credit where credit is due—I tried my best.

And I give my heart and support for all those fighting to keep culture alive in the East Bay. Let's do this thang.

INTRODUCTION

G **RAFFITI**—you either love it or hate it. Vandalism or art, does it belong in the gutter or the gallery? Everyone has an opinion and it can get heated! Personally, I love it, even the taggers. If you picked up this book then you are probably in the love-it camp, or maybe you're in the graffiti-curious camp, and maybe I can help out there. I've tried my hand at it myself, as a teenager and again in my early 20s. I was very bad at it, it's definitely not as easy as it looks, and it makes me appreciate it even more now. Being an urban girl, I see it as the art of the city. To me it makes cities more colorful, beautiful, and human. It is literally a human touch on the city.

I decided to create this book at the encouragement of Fonthill Media. They saw my pictures on the internet, which is nice, because sometimes you feel like you're sending your work into the ether, but someone saw it! And they liked what they saw! That's huge for an artist. So, when they proposed a book, I said, "Hell yeah, this is awesome!" I don't know if it will go anywhere, but it's still cool to be doing it. I'm happy to be a part of their *Abandoned Union* series and hope I can bring it a little bit of color.

I want to share with you what I see, so that maybe you can see the artistry in its pure raw form. Here's your look into a little part of the hidden city. I took my mom into a building—she was hesitant of course—but she quickly became amazed. Even still, she assumed there were beer bottles all over the floor and I had to point out to her that they weren't beer bottles, but spray paint cans! There was only one little case of beer off in the corner of this huge warehouse. People weren't going in there to drink and use, they were going in there to do art. And unless you can see the photographs from someone like me, you just aren't going to be able to see this part of the world that you might be driving by every day. It's like a geode that looks plain and ugly on the outside, and then you crack it open and there's these beautiful crystals inside, hidden gems.

I also want to share a little bit about the cities I photographed: Oakland, Berkeley, Alameda, and Richmond. I'm sorry if I missed your city, but I'm a photographer of opportunity. I carry my camera everywhere, and you are seeing what I stumble across in the cities I frequent. This is me going out and just noticing things, and then finding opportunities. It's the nature of this type of art that it doesn't last long, and if it's an abandoned building, then the building may not last long either. Plus, there are people that hate graffiti and will go around and cover it up (which I think looks worse)—you just never know, you have to strike when the iron is hot. Some of the images in this book may no longer exist.

By the way, if you know a spot, or want an urbex buddy, or are a graffiti artist that will let me follow you around, I would totally appreciate that. I'm always looking for new ways to get inspiration, so feel free to reach out to me.

This is my neighborhood. This is what the East Bay is, man, and I love it. It's color, life, energy, personality, a human touch in the urban environment. It's part of what makes the urban environment special. You see graffiti in smaller towns, but this is on another level. Especially Oakland—it draws some of the best artists. And for those who aren't as good, they have a full city to practice their craft in. It is an art form—I don't care what people say. It's paint and the canvas is the city, and that's art!

I sincerely hope you enjoy.

1

GRAFFITI

COLORFUL, surprising, interesting, and sometimes humorous, graffiti is also seen by some as a scourge of the modern world. This, however, is not true. The first known example of graffiti is from ancient Greece and is said to be an advertisement for prostitution (the oldest profession). It is also known to have been in the ancient countries of Italy, Egypt, Sri Lanka, Afghanistan, Iran, Guatemala, Ireland, and Constantinople. It encompassed crude images, political statements, and everything in between, much like the present day.

To be honest, yes—it is vandalism. Some graffiti artists are lucky enough to have people pay them to do sides of buildings. I, myself, reached out to graffiti artists to paint my box truck that I carry my art in. Today, I think it's safe to say that it exists in every major city worldwide, and in many smaller cities and towns. More recently, it can even be seen in the finest art galleries, with Banksy, Basquiat, and Keith Haring probably being the most famous. Banksy recently sold one of his pieces at Sotheby's for almost $1.9 million!

Graffiti can be done with spray paint, stencils, permanent marker, pencil, carving, and stickers, or even wiped into the dirt on a wall. The legal definition of graffiti is "any etching, painting, covering, drawing, or otherwise placing of a mark upon public or private property which is unsanctioned and un-commissioned." This last bit is what seems to irk most people. But it's also what gives the art form its energy, immediacy, and bad boy (and girl, and other) allure.

I think what's so cool about it is that it's so fresh. People are always trying new things, because they're not held up by standards of "this is what art should look like"—at least not the people who really stand out. There are a lot of young people involved, and young people are good at innovation, so that's what you're seeing. You're seeing young people's minds at work, and it's really exciting, alive, vibrant, and surprising. And I feel lucky to be able to see people working on their craft in the raw form.

I think it's also easy to look at taggers and bad graffiti and use it to judge the whole genre, but keep in mind that you are looking at artists in all stages of development. It's like you are getting a glimpse into an artist's sketchbook, or their first fumbling attempts in art school. The awe-inspiring thing about graffiti is that it is all, I mean all, out there for you to see. Imagine the bravery. Think of your first steps in whatever field you chose, and imagine an audience watching you every step of the way. Personally, I am very glad there were no cell phones recording when I was growing up!

Photographers have a long history with graffiti artists. As graffiti gained popularity in the 70s, the photographers followed, seeking out their hidden places and photographing the art gems before they disappeared. With the popularity of photo sharing sites like Instagram, photographers began sharing more and more photos, and graffiti art exploded in popularity. These days, there are "urbex" hunters only dedicated to exploring and shooting. To these people, the excitement is in the hunt, finding those spots that no one else sees and being in on, literally, the secret. It can be addictive, therapeutic, calming, and exciting, all rolled into one.

Whether you love it, hate it, or don't even notice it, graffiti is an important part of some people's culture. And in history as in the present, certain types of graffiti, like political statements or glimpses into other people's lives and minds, carries a powerful message, if you choose to listen.

Let's support our artists of all stripes, And thank these (usually young, by my standards anyway) people for allowing us to see their process.

2

THE EAST BAY

DO WE LOVE IT? Yes, we do. Is it getting increasingly expensive and gentrified? Sadly, yes. It is also mobilizing people to hang onto and fight for the culture here. And do we have culture: music, food, events, styles, ethnicities, identities, and art. Vibrant, alive, ever changing, and building on the past.

People in the East Bay love the East Bay, like people in New York love New York—it's the same thing. The San Francisco East Bay consists of cities that sit directly on the east side of the San Francisco Bay, with San Francisco sitting on the west side. From north to south, these cities consist of Richmond, Albany, Berkeley, Emeryville, Oakland, Alameda, San Leandro, Hayward, and Newark, with the concentration running from Richmond to San Leandro. This concentrated area is generally referred to by locals simply as "the East Bay."

The East Bay? People love it. It's part of an identity, especially Oakland and Berkeley. If you live in those two cities, you really own it. It's part of your identity and who you are. San Francisco is great, but in the East Bay you can park your car, you can get from place to place, it doesn't take twenty minutes to drive a mile, and there are lots of parks. You've got this mix of urban with a small town feel at the same time.

You've got everything you want here. A lot of people from the East Bay don't even go over to San Francisco because we've got everything we need. The vibe is a little different, a little slower, and the people are friendlier (not everywhere!). There's more of a community feel too, if you can find your people. This exists in San Francisco, too, but there's a little more of a feeling like you're on your own in SF. At least that was my experience in the city. The East Bay feels more personable.

Each city has its own specific personality. Richmond is a gritty, sprawling, industrial and suburban neighborhood that is redefining itself as a cultural hub. Tiny Albany is best known for its horse racing and its artistic waterfront park. Berkeley is home

to various countercultures and college students. Emeryville is an artist's haven with condos, houses, and open-air malls. Alameda is a quaint island town with a foot firmly in the retro past. Oakland is alternately beautiful and gritty, family oriented and urban, with a rich cultural history and a strong and growing arts community. Finally, often overlooked San Leandro is primarily urban and suburban sprawl.

In my photographic journeys, I ventured to all these East Bay areas except San Leandro. Except for the best thrift store around, in my honest opinion, there is not much reason for me to go to San Leandro. San Leandroans, I hope you forgive me, and please feel free to prove me wrong.

3

OAKLAND

OAKLAND can be a hard place. Some of the poorer areas will really wear you down. But it also has beauty. Oakland is a major West Coast port city and the fifth busiest port in the United States. It is the largest city in the East Bay and the third largest city in the entire Bay Area. It is the eighth most populated city in California, and the forty-fifth largest in the United States . It has a population of 429,827, according to the 2018 census; however, the large homeless population living in shelters, vehicles, and tent cities raises that number by 4,071. It is estimated there are 7,676.46 people per square mile.

There are so many different types of neighborhoods all wrapped up into one city. You've got the hills and Piedmont where the rich people live. Claremont is where the boutique shops can be found. East Oakland can be rough, and West Oakland is kind of undercover rough. Both East and West Oakland probably account for most of the 18.7% of people who live below the poverty line (higher than the national average). Lake Merritt is a vibrant community spot in and of itself and that is also true of that whole surrounding area. And the Raiders man, we love our Raiders. I still hold out hope that they will come back to us.

Gentrification is steadily pushing out people that have lived here for generations, solidifying the remaining residents. Oakland is home to Barbecue Betty and is where Fruitvale Station was filmed. It is also home to the Black Panthers, and is said to be experiencing a phenomena similar to the Harlem Renaissance.

Oakland requires businesses to remove graffiti on their own, and relies on residents to report graffiti on city-owned properties. All of this creates a long-standing history of graffiti. People come from across the country to graffiti here, and up-and-comers find many sources of local inspiration and guidance. Because of this, my largest selection of graffiti photos comes from here, and I expect many more. Enjoy.

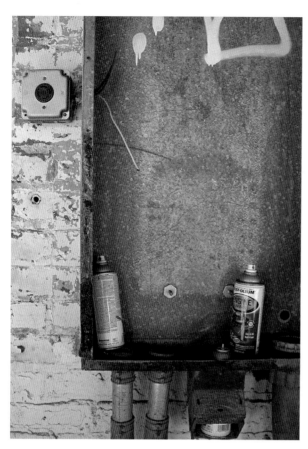

▲ Oakland – RUST-OLEUM ENGINE
 ENAMEL
▼ Oakland – RUST-OLEUM METALLIC
 FINISH

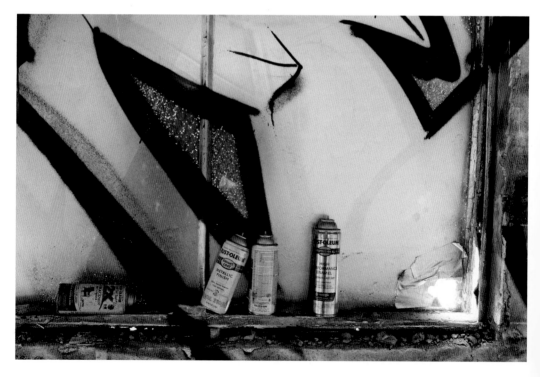

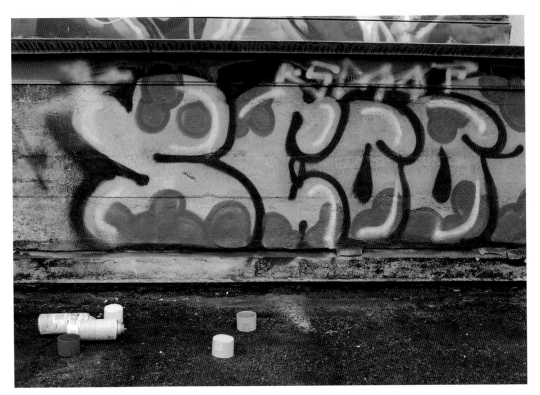

Oakland – SCOOT

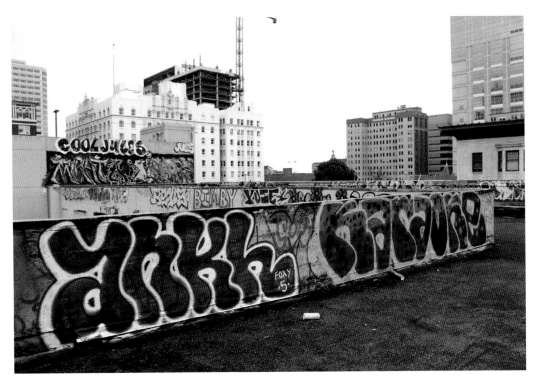

Oakland – JULES/ankh/BIMBY

Oakland – Oakland Pigeons

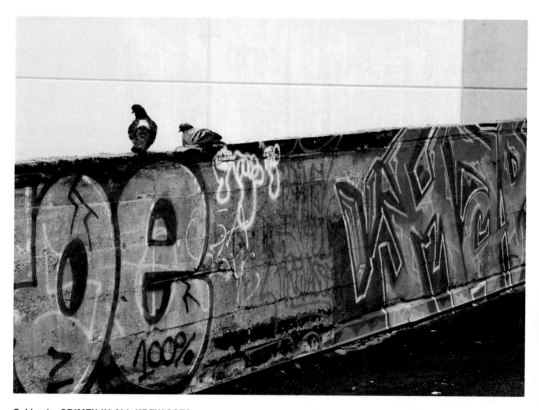

Oakland – GRIMEY IN ALL KREVASSES

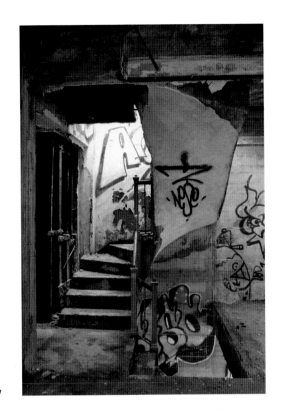

▲ Oakland – NESE
▼ Oakland – Grey Decay

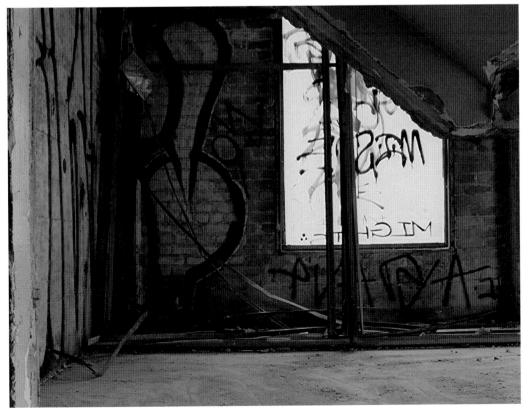

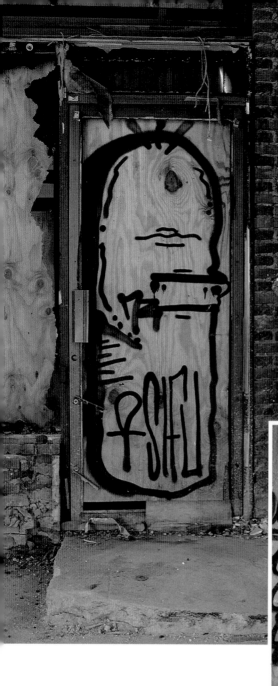

▲ Oakland – SIFU
▼ Oakland – RESSA ONER

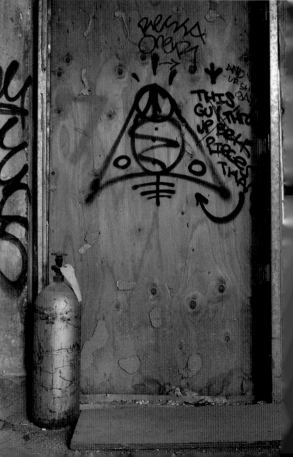

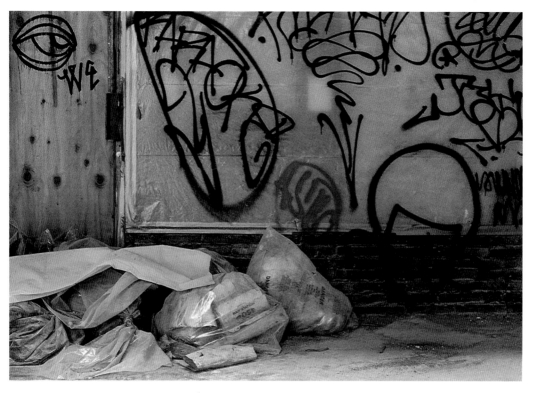

Oakland – WE/KARAOKE

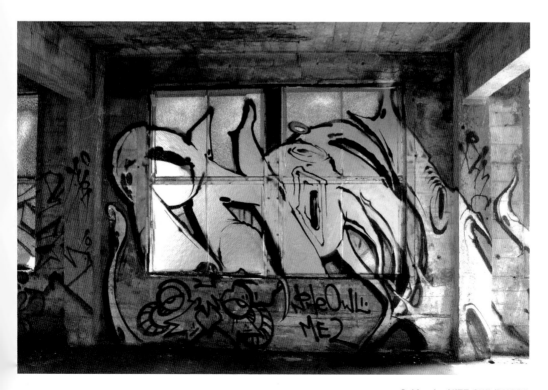

Oakland – NiTE OWL/PHORA

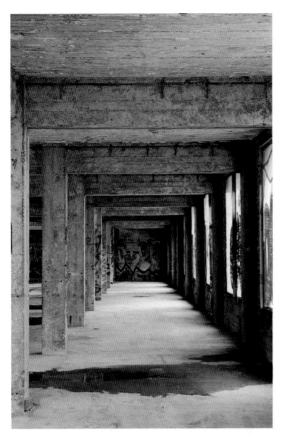

▲ Oakland – Perspective
▼ Oakland – Perspective Detail

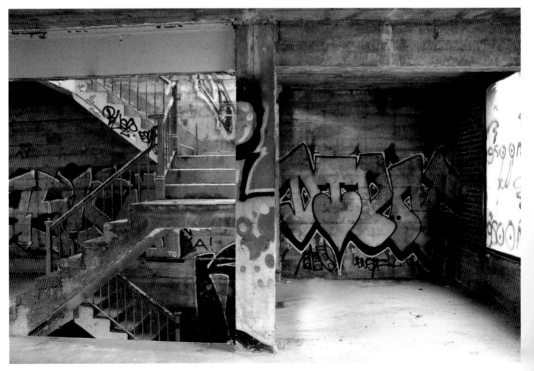

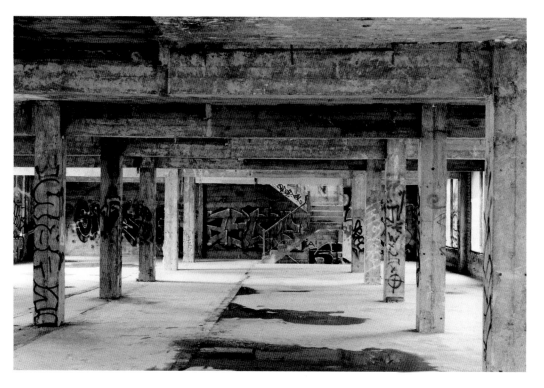

▲ Oakland – Staircase
▼ Oakland – Staircase Detail

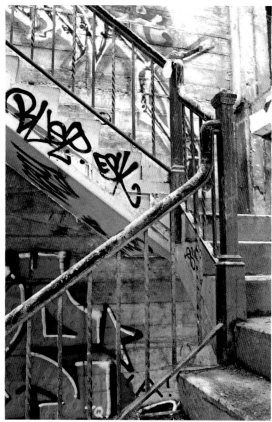

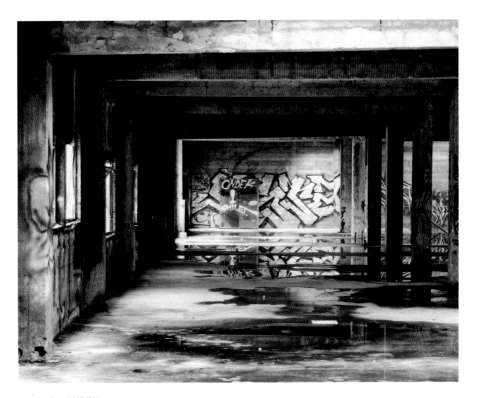

Oakland – ONDEK

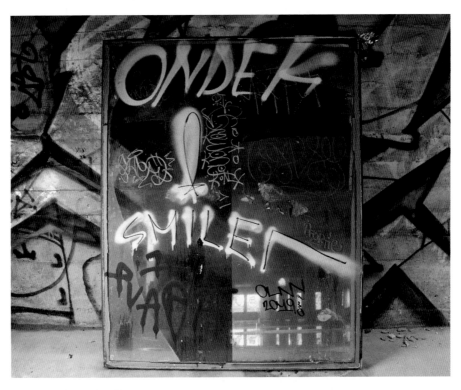

Oakland – ONDEK Detail

▲ Oakland – Study in Green
▼ Oakland – Study in Blue

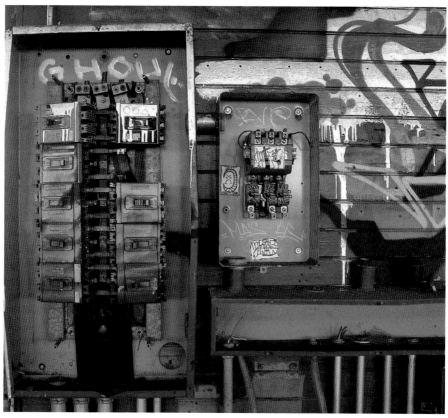

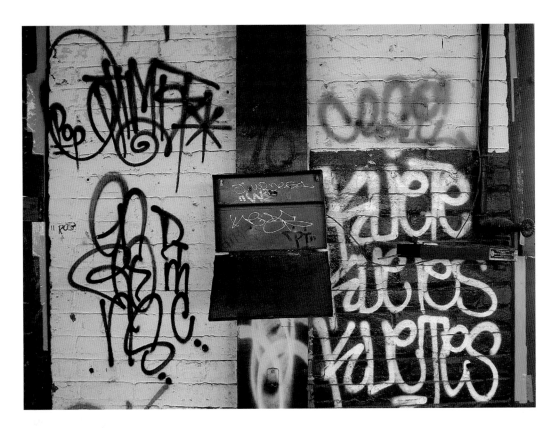

▲ Oakland – **KUETES**
▼ Oakland – Hanging Electrical

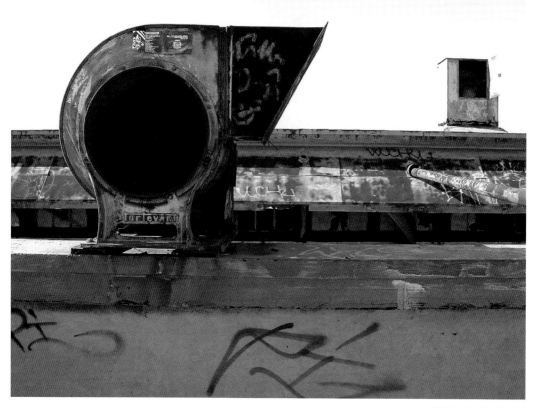

Oakland – Sturtevant

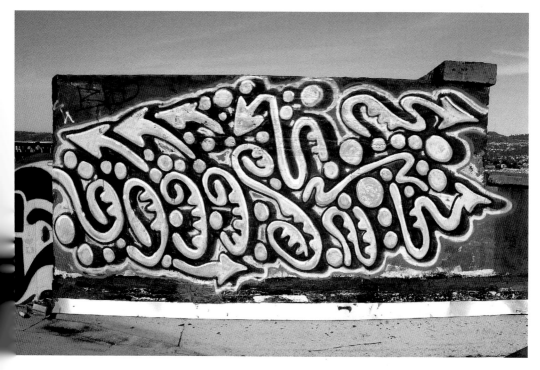

Oakland – Abstract With Arrows

▲ Oakland – Rust
▼ Oakland – West Oakland Roof

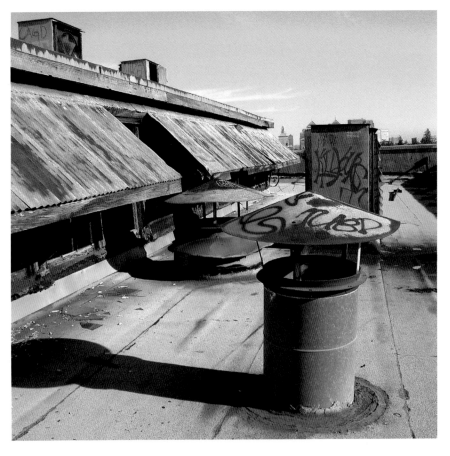

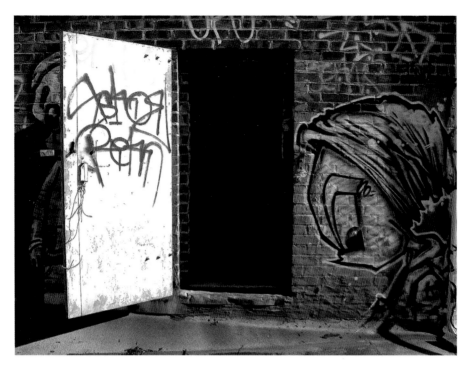

Oakland – **KNOWNR**

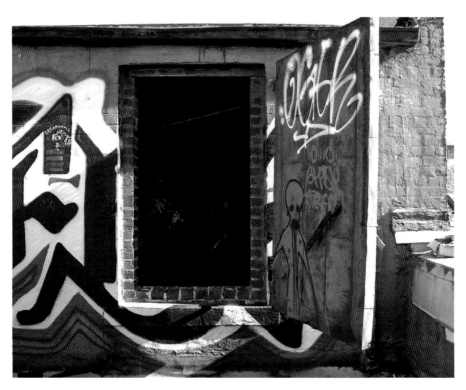

Oakland – **DREAM SMALL/OGER**

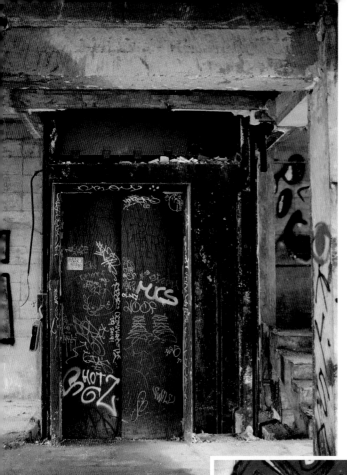

▲ Oakland – Door Tags
▼ Oakland – **OSCAR GRANT**

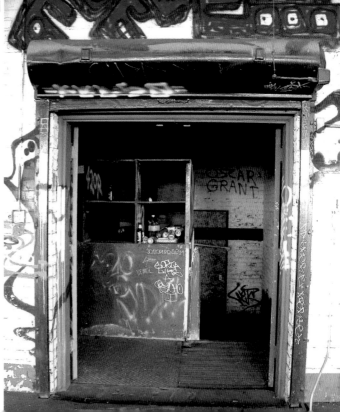

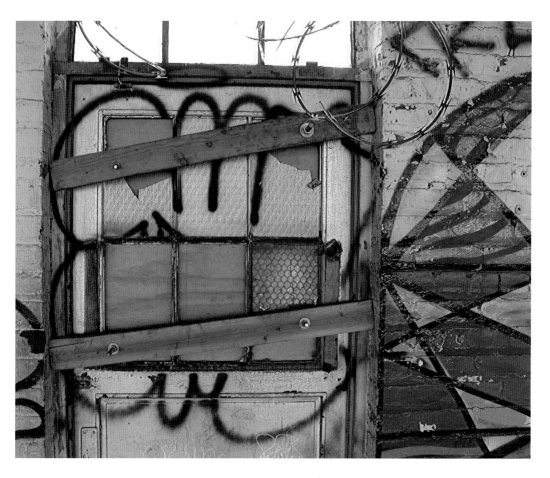

▲ Oakland – Lines and Lines
▼ Oakland – Broken Heart

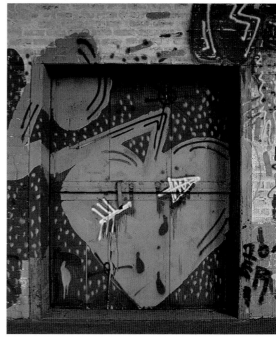

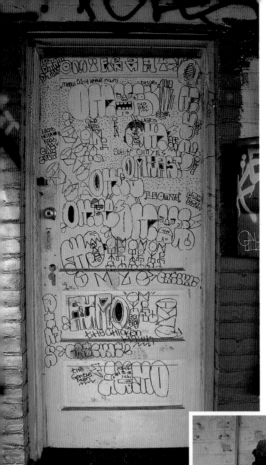

▲ Oakland – Pen Art
▼ Oakland – Gritty Doorway

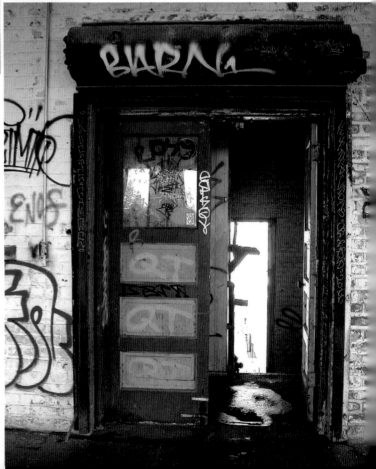

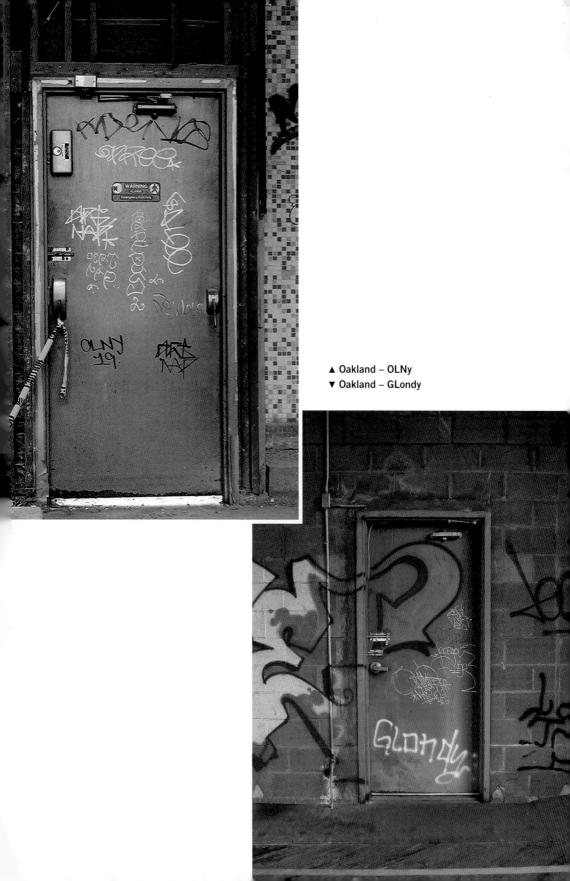

▲ Oakland – OLNy
▼ Oakland – GLondy

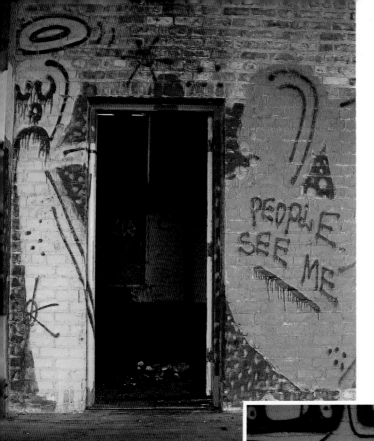

▲ Oakland – PEOPLE SEE ME
▼ Oakland – KELSO

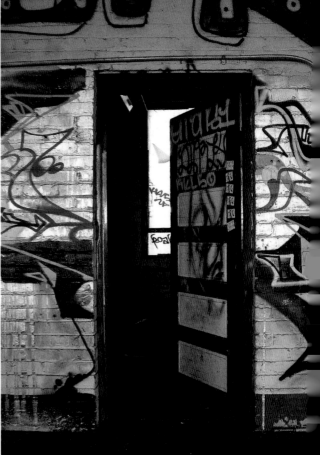

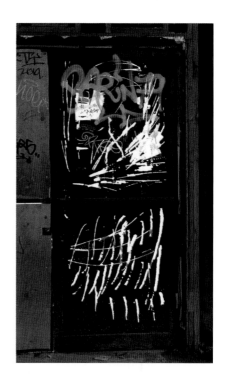

▲ Oakland – Scratch Art
▼ Oakland – Downtown View

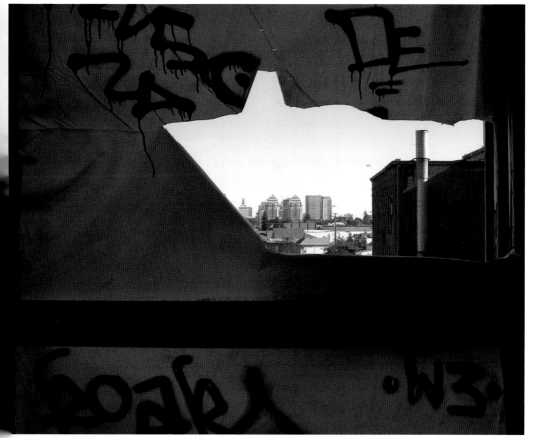

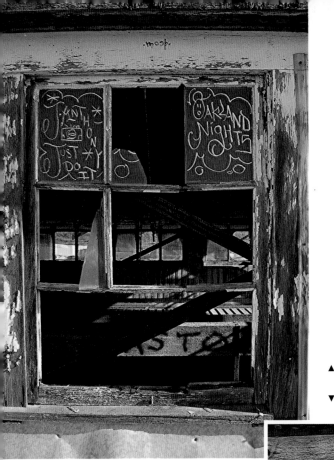

▲ Oakland – **J-ANTHONY/JUST DO IT/**
 OAKLAND NiGHTS
▼ Oakland – Swampy Sticker

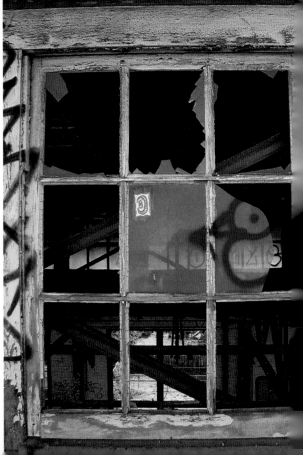

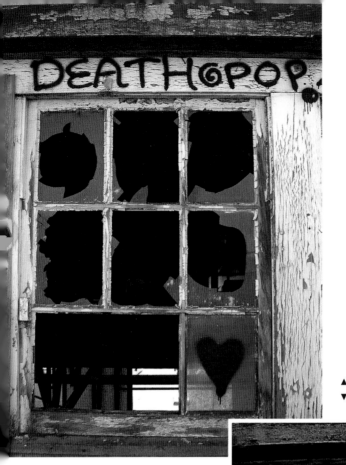

▲ Oakland – **DEATH POP**
▼ Oakland – **CHEAHH!!**

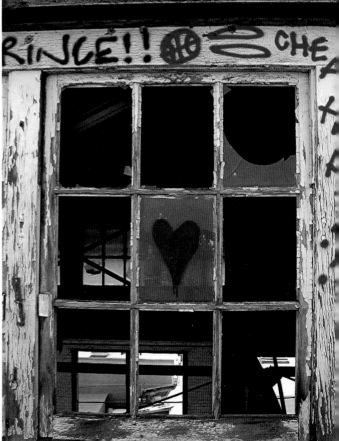

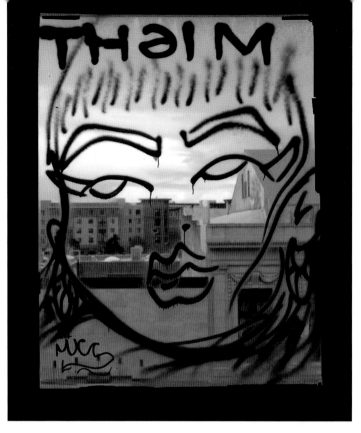

▲ Oakland – THeIM
▼ Oakland – ICU

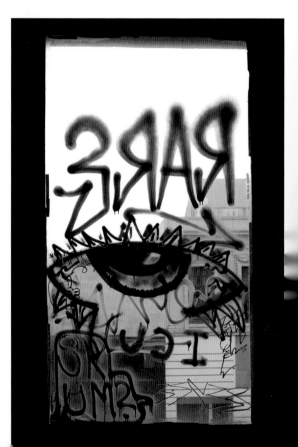

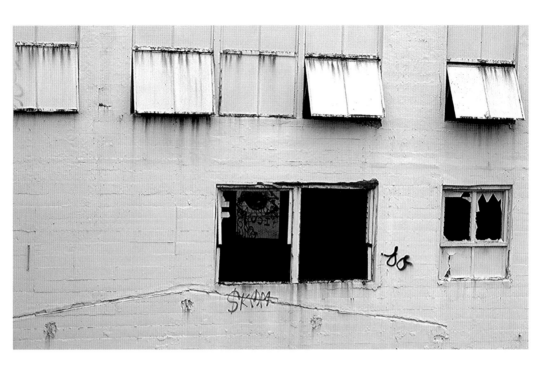

▲ Oakland – ICU Through a Window
▼ Oakland – Pink Eye

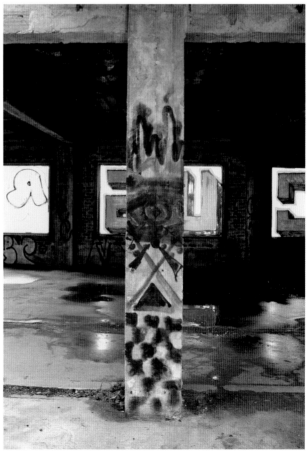

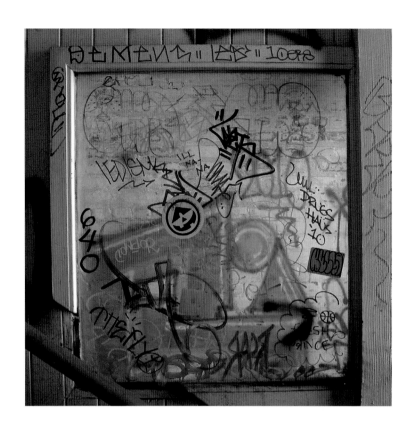

▲ Oakland – Mirror
▼ Oakland – ODDCREW

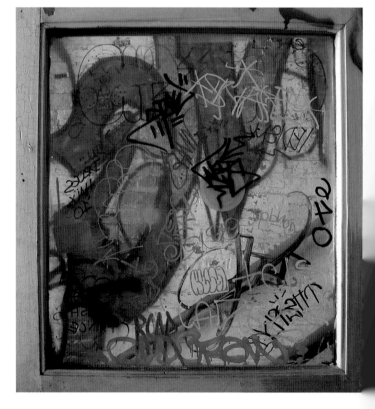

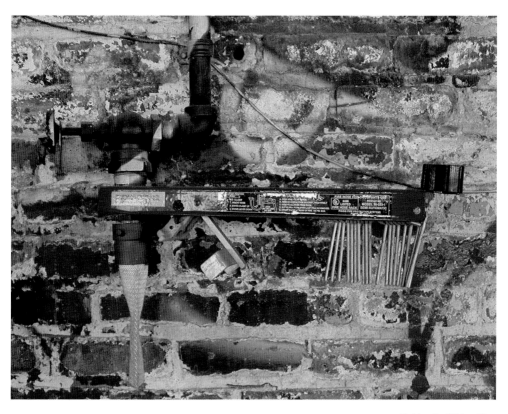

Oakland – Water Pipe

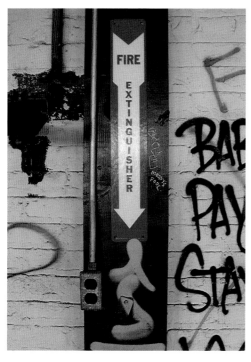

Oakland – FIRE EXTINGUISHER

Oakland – Don't WAKe ME

BERKELEY

ULTRA-LIBERAL **BERKELEY** is probably best known as a major player in the summer of love. Up on Telegraph Avenue you can still see remnants of this past, with tie-dyed vendors selling their wares to college students. I guess today it could be called neo-hippy, but people who live there actually don't like this rep. Believe it or not, there are a lot of residents who don't like the hippy scene and are very against the neo-hippy New Age vibe, but nevertheless, that's what it's known for. But more than that, there are a lot of college students. It's definitely a college town that caters to college kids. There's lots of shops and places to eat that are suited to a college budget and lifestyle, and there are five movie theaters with various options from blockbusters to art films.

Its population is much smaller than Oakland: 121,643 people at the last census, with the homeless increasing that number by 1,108. It hosts the impressive campus of the University of California Berkley and is estimated to serve 40,000 students in approximately 350 undergraduate and degree programs. Its thirty-two libraries together make up the fourth largest academic library in the United States. The college team here is the loved and respected California Golden Bears, and on game day fans take over the city. Students are less radical than in the turbulent sixties, and the economy is more stable than in Oakland.

Although Berkeley has a long history of graffiti street art, most of the graffiti is limited to dense hotspots. One of these hotspots is an abandoned three-story warehouse. Long an illegal graffiti spot, in 2012 it was opened to select artists to add some grand final pieces before it was demolished. The demolition never happened, and it continues its colorful tradition. These photos are but a shadow of what I saw and experienced in this wonderful site. I'm attempting to contact the owner and hope to get back in someday.

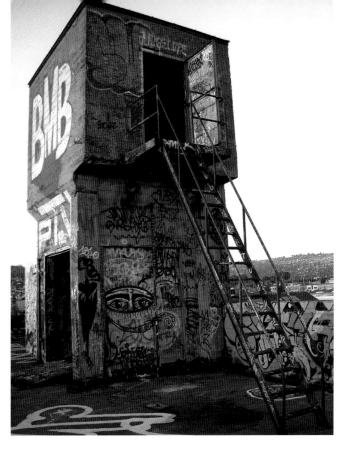

▲ Berkeley – Sunset on the Roof
▼ Berkeley – PTV

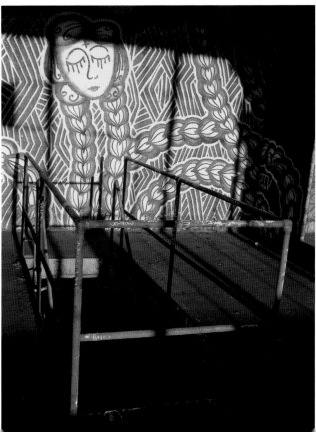

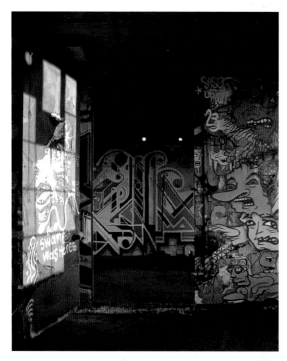

▲ Berkeley – Swampy Was Here
▼ Berkeley – Girl In Distress

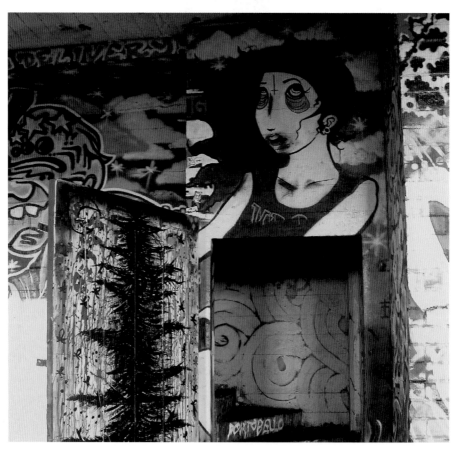

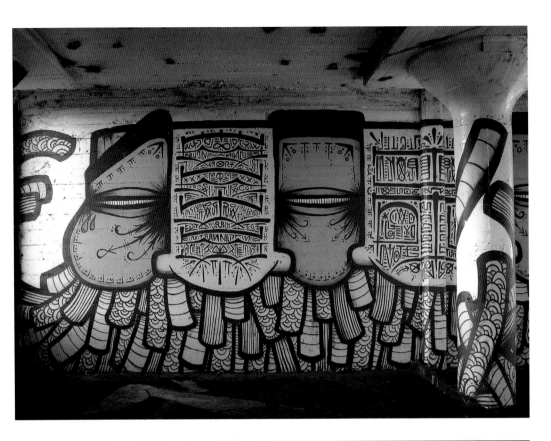

▲ Berkeley – GATS
▼ Berkeley – Through the Circle

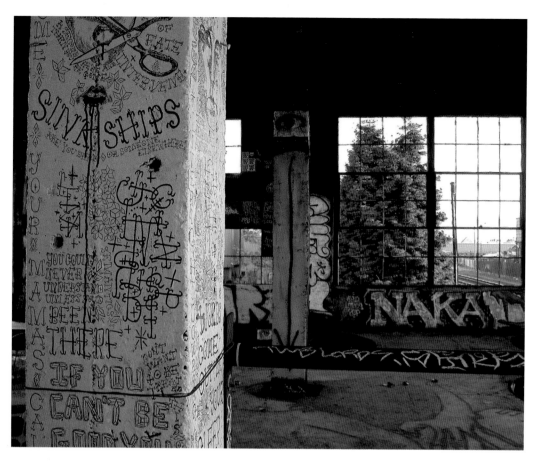

▲ Berkeley – LOOSE LIPS SINK SHIPS
▼ Berkeley – SLEEP WALKER

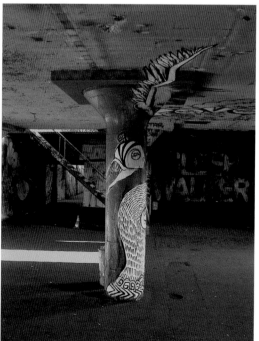

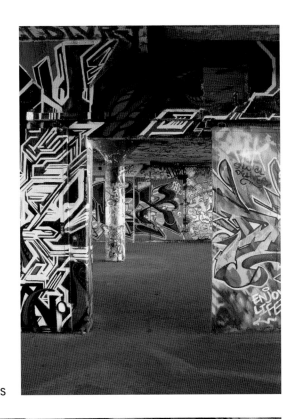

▲ Berkeley – TAK
▼ Berkeley – EX VANDALS

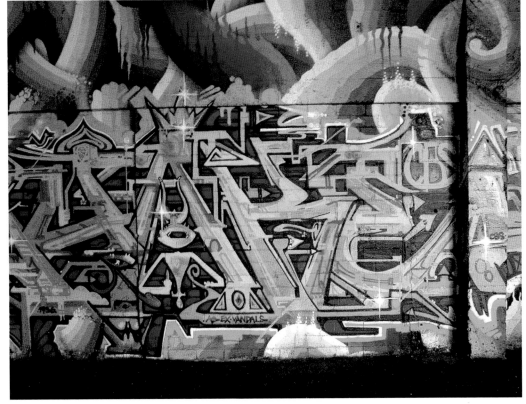

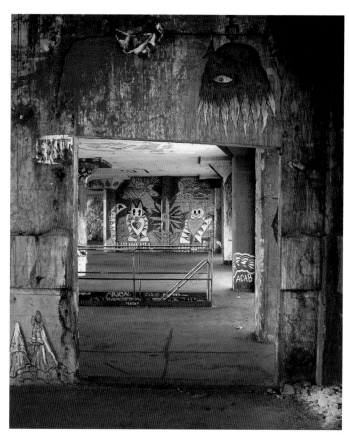

▲ Berkeley – Through Hell
 To Cat Heaven
▼ Berkeley – Mosaic Graffiti

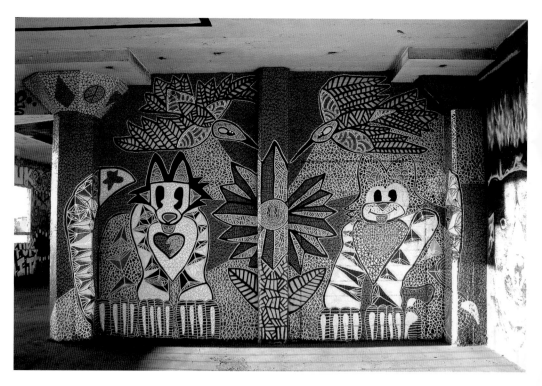

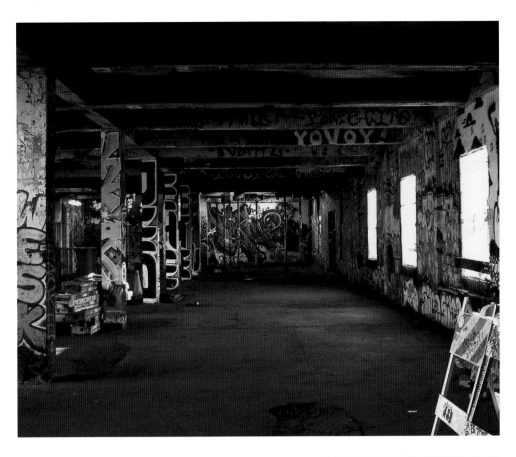

▲ Berkeley – **YOVOY**
▼ Berkeley – **YOVOY** detail

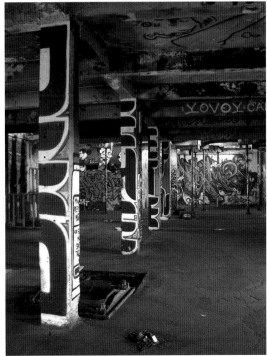

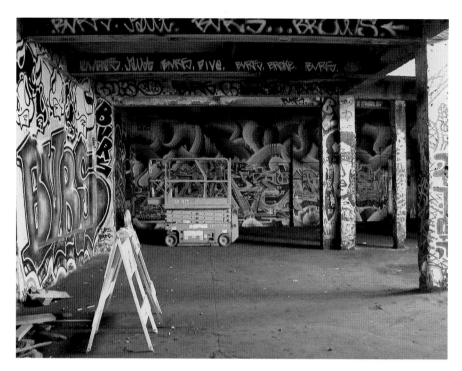

Berkeley – BVRS

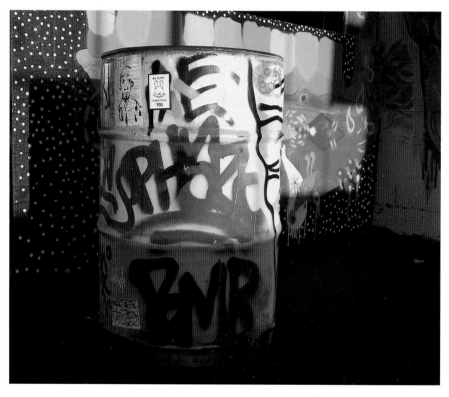

Berkeley – Garbage Can

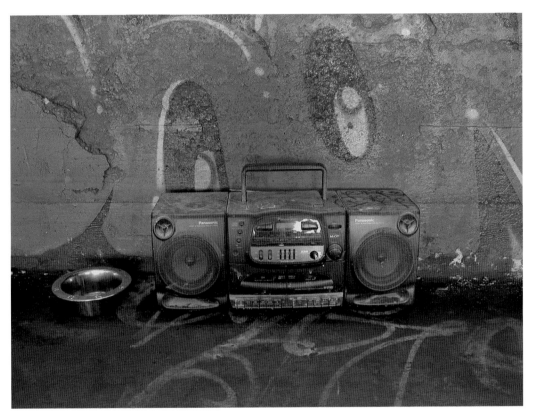

Berkeley – Boom Box

5

EMERYVILLE

EMERYVILLE is my current hometown. Incorporated in 1878, it was once known as the "Rottenest City on the Pacific Coast" due to its many city sanctioned "immoral" activities. It is nestled in a pocket between Oakland and Berkeley, and bordered by the bay. Currently it is a small, quaint, and diverse city, home to many artists. It is divided by train tracks, with condos and small commercial outdoor malls on one side, and houses and tiny parks on the other. I wouldn't live anywhere else. It has this one warehouse that has been abandoned for years. First the graffiti artists got in, then the homeless and the scavengers. At one point, there was a fire that destroyed one of the buildings, and I was unwittingly inside it as it smoldered! I was lucky enough to be able to photograph various iterations as it kept changing, inside and out, like a living being.

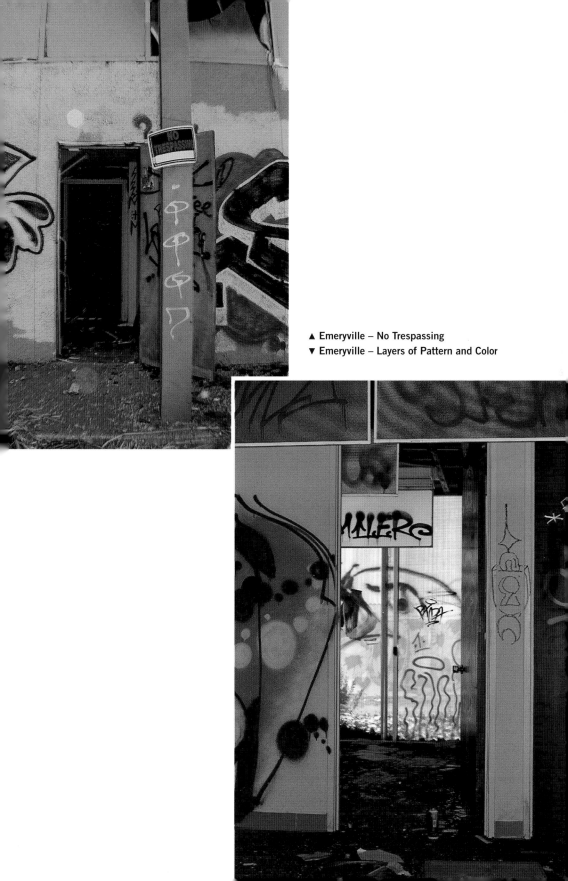

▲ Emeryville – No Trespassing
▼ Emeryville – Layers of Pattern and Color

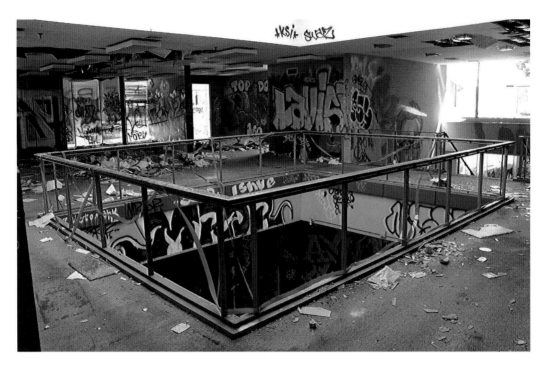

Emeryville – KSi/SWAZ

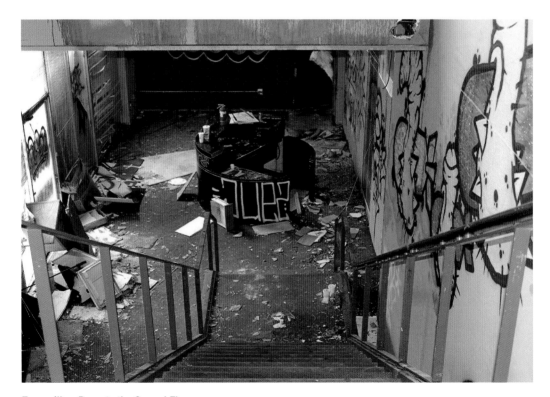

Emeryville – Down to the Ground Floor

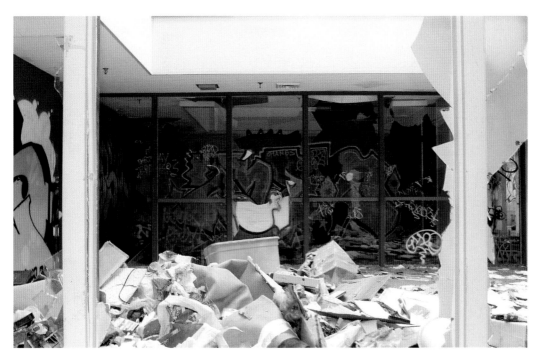

Emeryville – Window Room

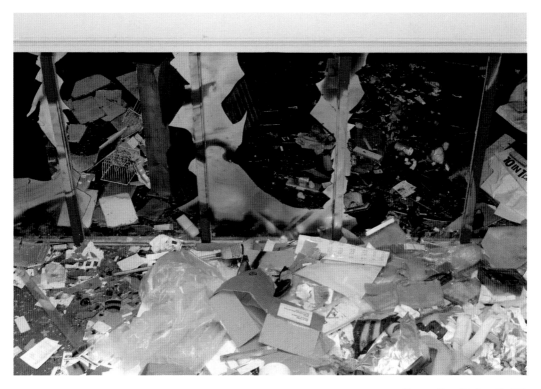

Emeryville – Broken Graffiti

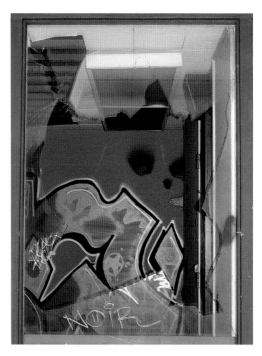

▲ Emeryville – Window Room Detail #1/NOiR
▼ Emeryville – Window Room Detail #2/NOiR

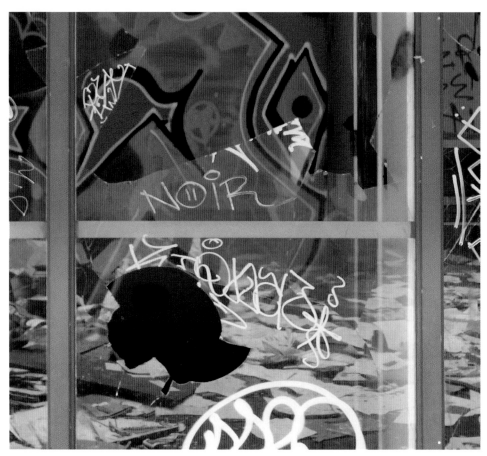

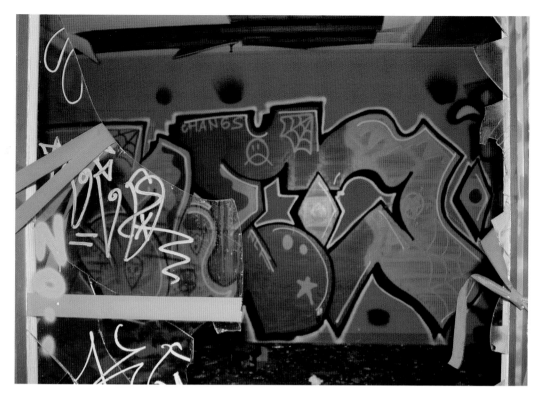

Emeryville – Window Room Detail #3/CHANGS

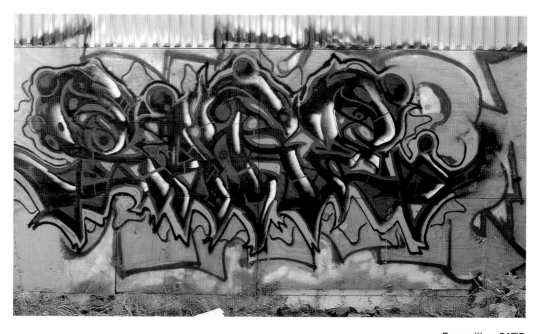

Emeryville – SATiR

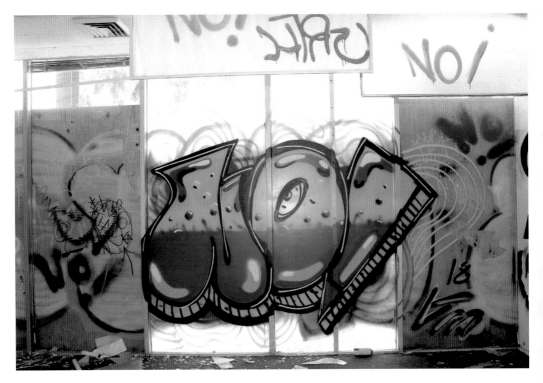

Emeryville – No!

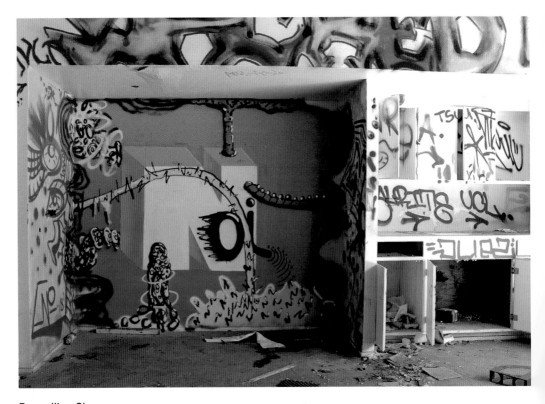

Emeryville – Oi

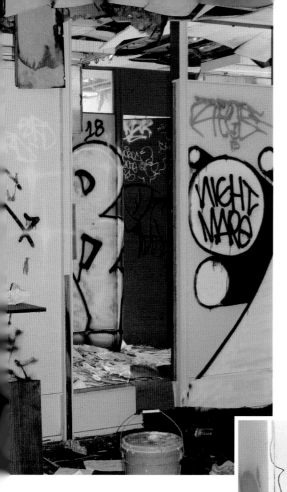

▲ Emeryville – NIGHT MARE
▼ Emeryville – EXIT

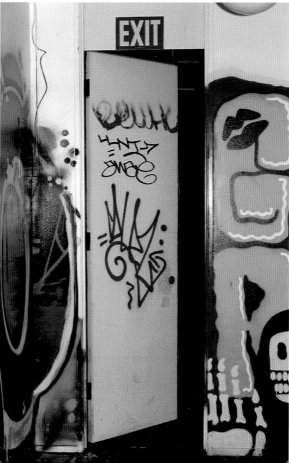

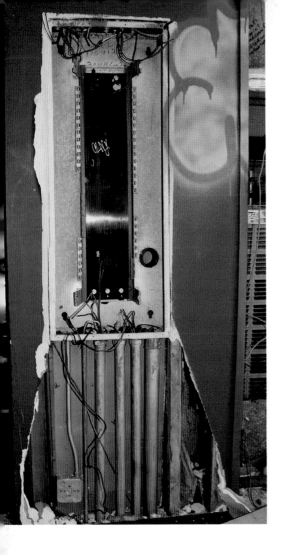

▲ Emeryville – Copper
▼ Emeryville – The Broom

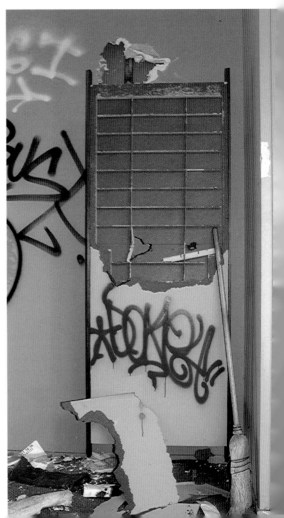

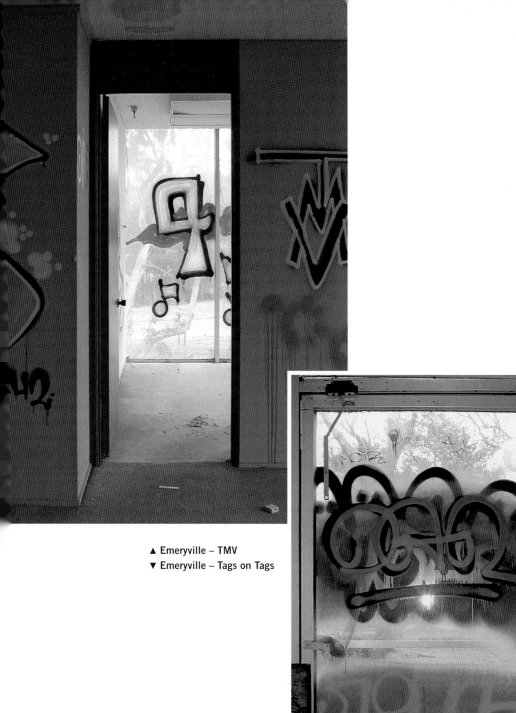

▲ Emeryville – TMV
▼ Emeryville – Tags on Tags

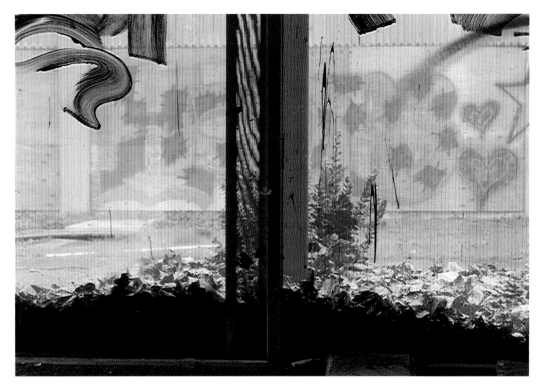

Emeryville – Pink View Outside Detail

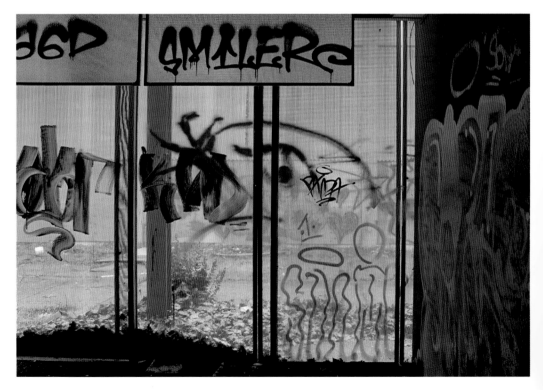

Emeryville – Pink View Outside/SMILER

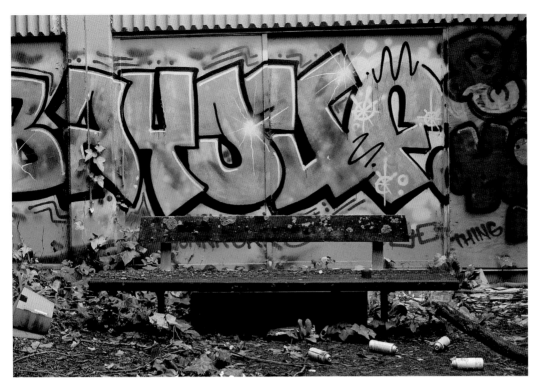

Emeryville – THING

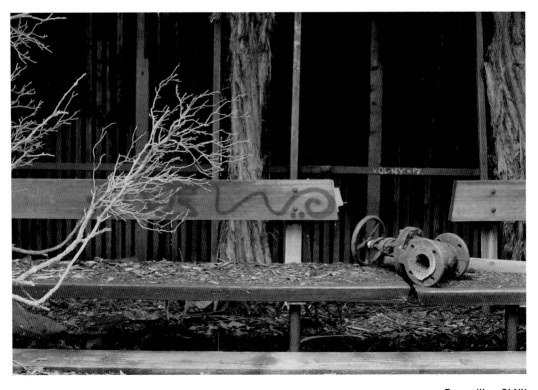

Emeryville – OLNY

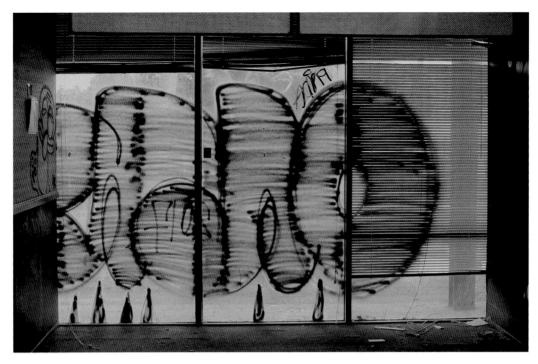

Emeryville – Venetian Blinds

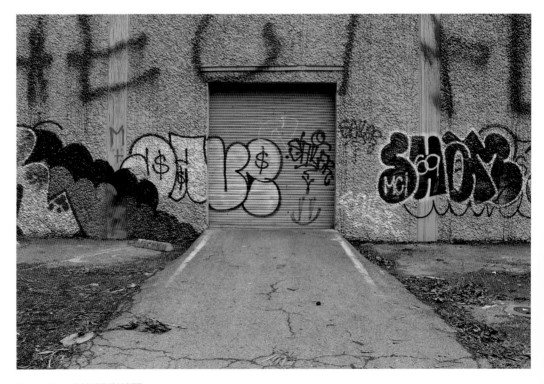

Emeryville – SAiLER/SHOTZ

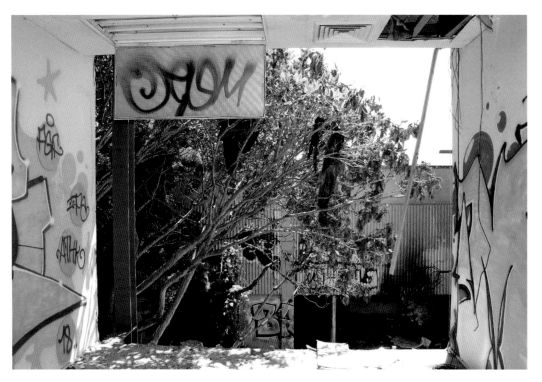

Emeryville – The Tree

6

ALBANY

ALBANY is a city I don't think about much. It's right next to me, but the only reason I go to Albany is really for the Albany Bulb. I love it. It is the only artistic thing you need to know about Albany. The Bulb is a former landfill that swells out over a mile into the bay, and it also gently rises as a hill that leads you to walk down the other side to the water, and it's beautiful. Nature has reclaimed it.

In the 1870s, the tidelands off Albany were sold by the state, as railroads extended tracks northward along the waterfront. The Bulb, named because of the shape, was created in 1963 when tons of construction debris was piled here. You can still see the concrete and rebar— however, it was quickly reclaimed by nature, and it is now home to many wildlife species.

Many ideas were planned for the space, but none came to be. Starting in the early 1990s, the homeless moved into this unincorporated area, and it was renamed by some "the Bums' Paradise" and the people that live there "the Landfillians." They were all evicted in 2014, but between those years, quirky, unusual, beautiful, and awe-inspiring artwork were created from the debris and other found objects, peaking in 1996. Over time, it has deteriorated, but beauty still remains, and has been added to by graffiti artists and others. I really enjoy hiking around there and seeing what new and old art I can find in different nooks and crannies. It's my favorite destinations in the East Bay. It's a shame all those creative "bums" got kicked out.

More recently, it has been reclaimed as a regional park. It, too, is being gentrified. It has had a resurgence of art trying to be brought in, but it's just not the same as when the homeless were there, and the graffiti artists came in. They both have an edginess that is lacking with the city sanctioned artists and art making tours that go through there. I really wish the homeless artists were still there. I think a lot of homeless are the creative people that don't really fit in anywhere else, and that was reflected in their art, and it was beautiful. I miss what it was. Just being able to go out there and discover hidden art was great.

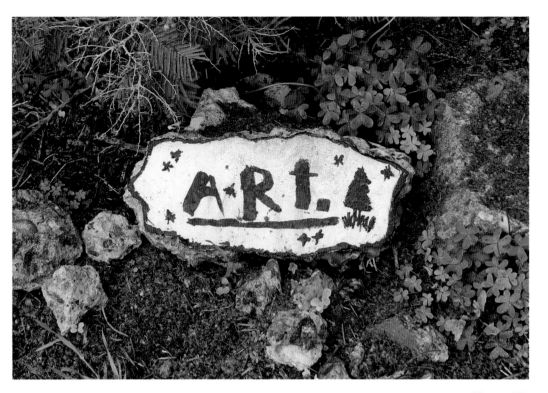

Albany – ARt

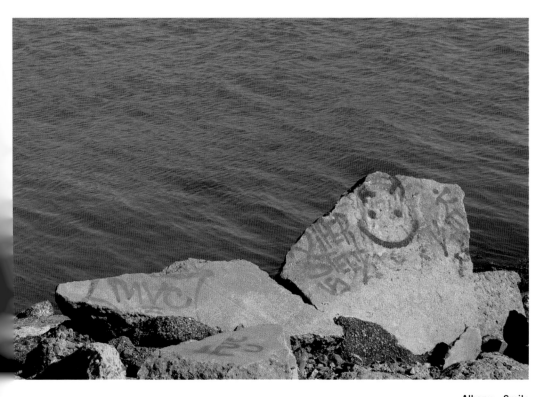

Albany – Smile

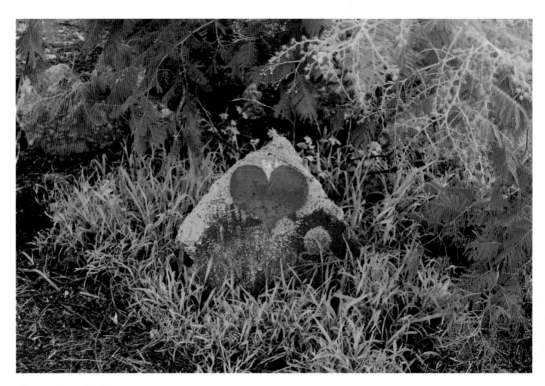

Albany – Heart Rock

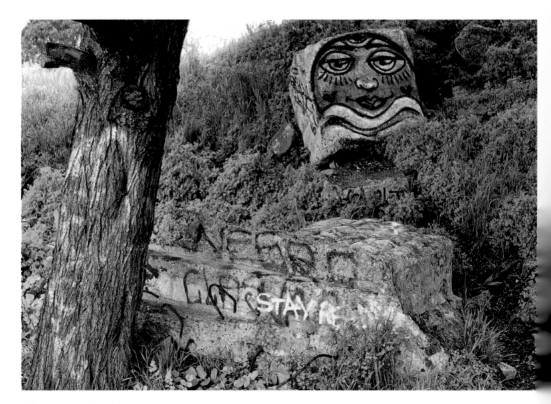

Albany – STAY READY

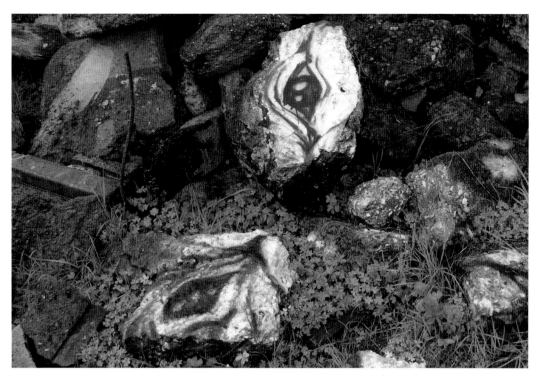

Albany – Eyes

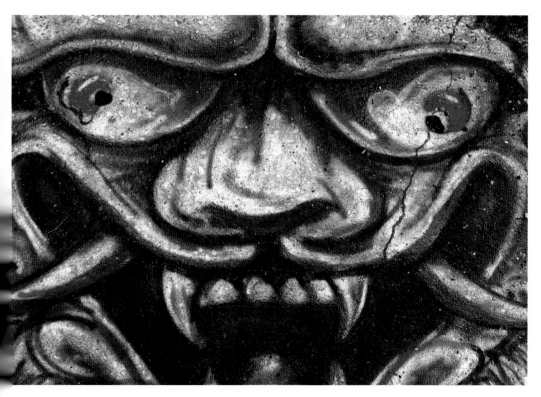

Albany – Dragon Face

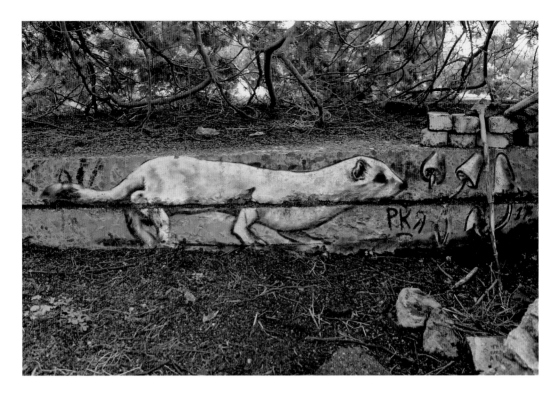

▲ Albany – PKA/Ferret
▼ Albany – Yellow Brick Road

Albany – EBRPD Albany – ELAB

Albany – Colorful Tree

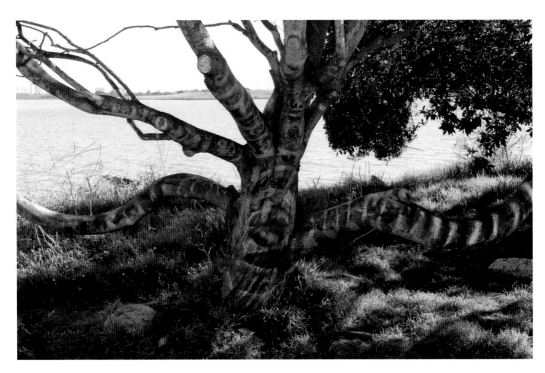

Albany – Striped Tree

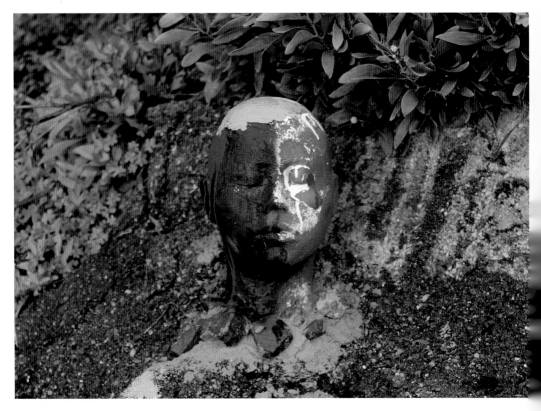

Albany – Colorful Head

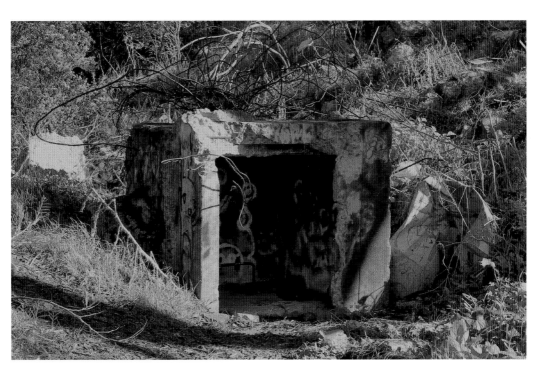

▲ Albany – Concrete Cave
▼ Albany – Looking Through The Door

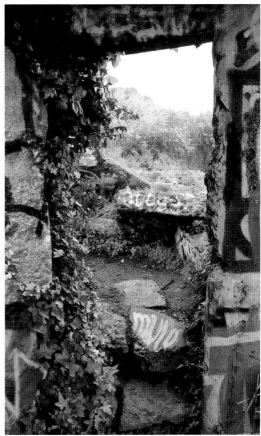

Albany – The Roof

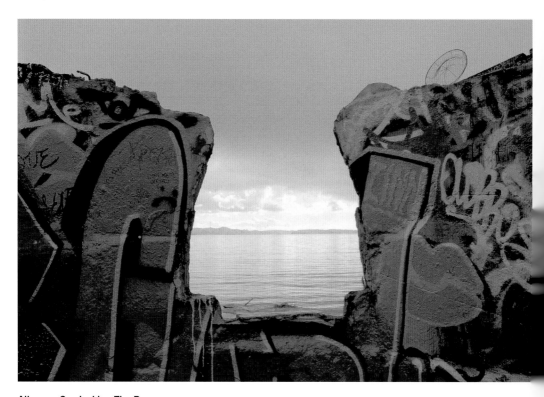

Albany – Overlooking The Bay

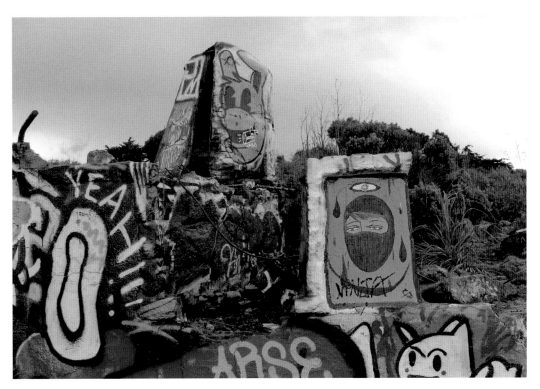

Albany – The Tail/NiNJA/YEAH!!!

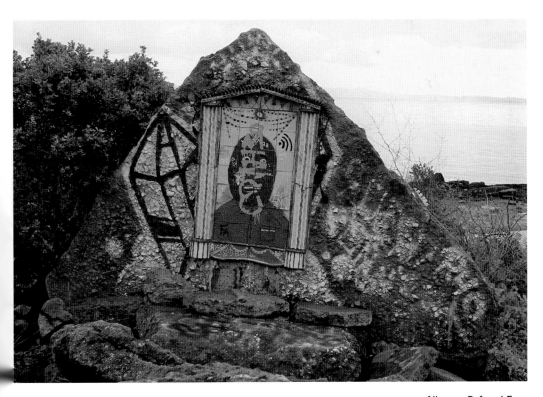

Albany – Defaced Face

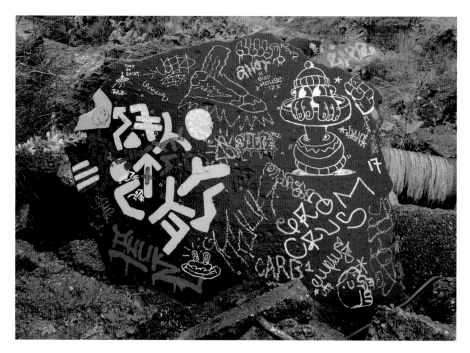

Albany – Line Art

Albany – Pipes

7

ALAMEDA

ALAMEDA is an anomaly next to bustling, urban Oakland. It's a quiet, quaint little island town with a 50s vibe. There's a lot of retro shops and the movie theater is a beautiful old restored theater in the grand fashion. It has a nice family-oriented beachfront for the kids. It is more affordable and less crowded than nearby San Francisco, and has a small-town feel.

It is an actual island, connected to Oakland by a short bridge at one end and a tunnel on the other. Drive over and you enter a whole other world. It was nicknamed "Mayberry by the Bay" due to its small size, quaint shops, and friendly residents. Not surprisingly, crime is very low. The homeless are given shelter on an abandoned military base which also houses a cheap nursery with edible plants, a bike repair shop, and its one skate park. Sometimes they have concerts at the skate park, they're trying to do things with it, so that's cool.

I used to work in Alameda, and needless to say, I was surprised when I found a warren of abandoned warehouses, used by graffiti artists and the island's small number of addicts. When I tell people this graffiti is from Alameda, they are also always shocked, because it doesn't really match with how you think of the island. It is short but sweet, and I hope you enjoy this selection.

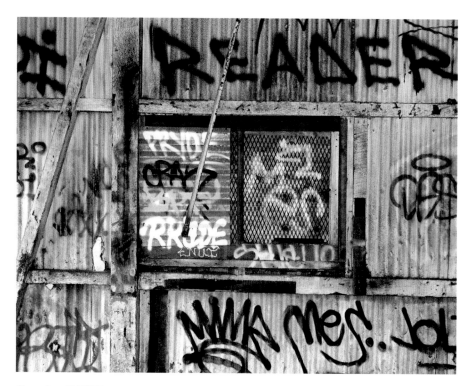

Alameda – READER

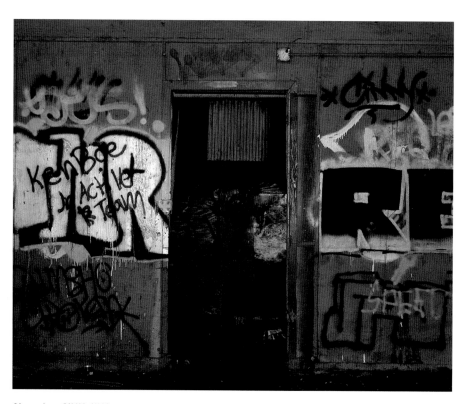

Alameda – CiNNy/JUS

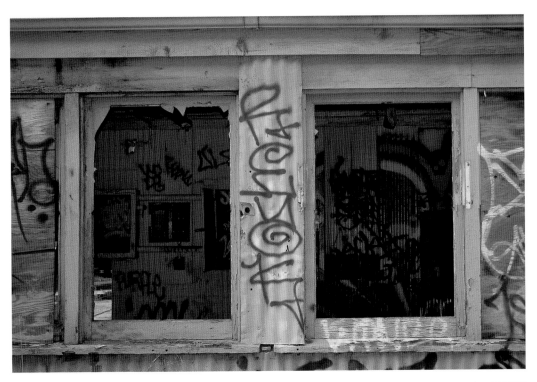

Alameda – RENOK

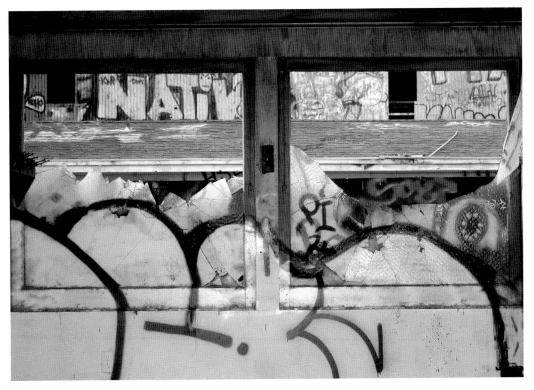

Alameda – NATiV/KAMA/PI

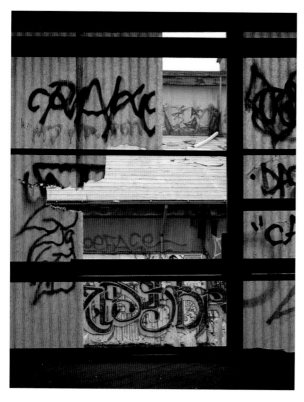

▲ Alameda – DeFACe
▼ Alameda – guiLty

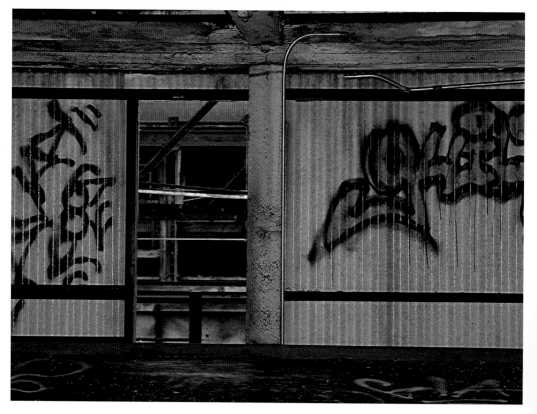

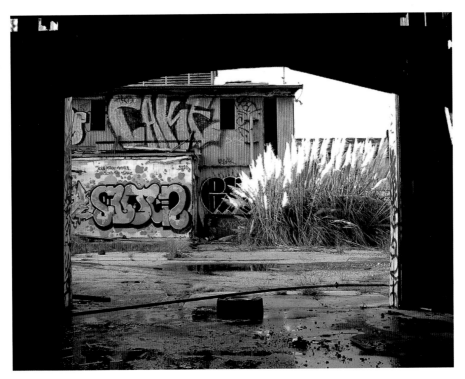

Alameda – CAKE

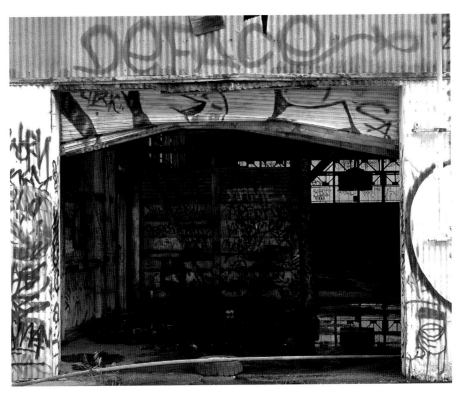

Alameda – DefFACe/GATS

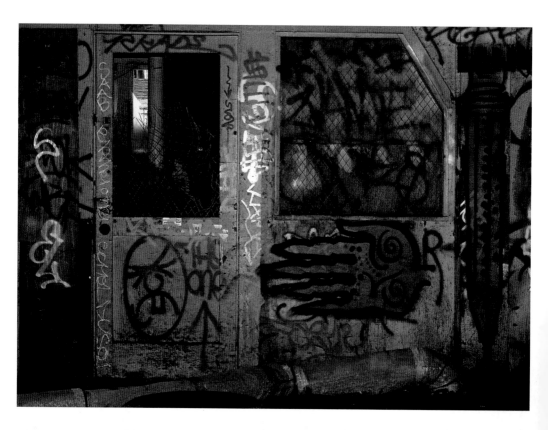

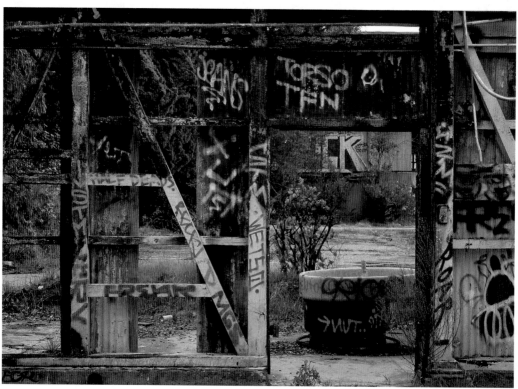

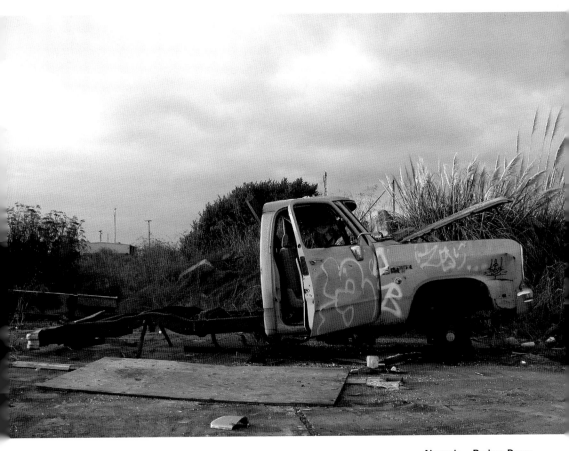

Alameda – Broken Down

▲ Alameda – THe One
▼ Alameda – TORSO/WETSO/STM

8

RICHMOND

RICHMOND is a rough town known for its high crime rate. There are some blocks that the police just won't go in. But there's also really beautiful areas around Richmond, too. There are little pockets of nice neighborhoods, the well known Richmond Art Center, and a beautiful waterfront area. Richmond's waterfront is 32 miles long, more than any other city in the Bay Area. It is open and welcoming, and full of spots to barbecue. The surroundings neighborhoods are lovely as well. It's here that I happened upon the little gem of an abandoned area that you see in my photographs.

Like Alameda, there is little reason for me to regularly visit Richmond. When you're surrounded by Oakland and Berkeley, you don't need to go much further. But Richmond is having a resurgence. It is letting people know about its art, playing up its cultural aspects, and making the downtown more vibrant and welcoming. Richmond currently has over thirteen underrepresented art centers and museums that I'm slowly discovering.

As I said, my experience here is limited. I'm sure there's more to the area, but Richmond is still a place that I'm a little wary of. I hope to be going into there more and getting more photographs. I'm trying support the city in making it a place where people want to go. I think that'd be great, because it's mainly my Black and brown people out there, and if I can support them with my presence, then I'll do it.

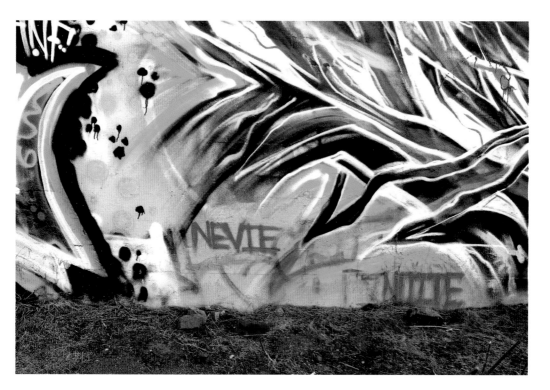

▲ Richmond – NEVIE/NOITE
▼ Richmond – NOITE detail

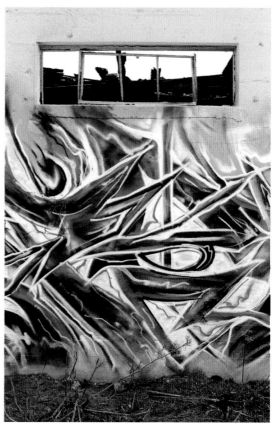

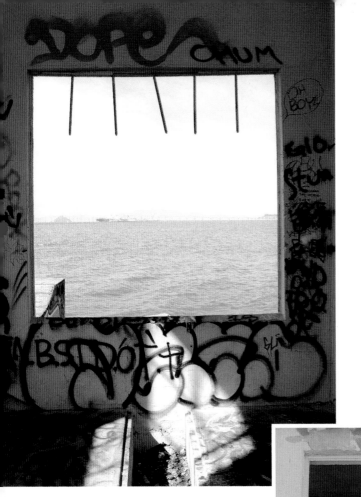

▲ Richmond – DOPe/CHUM
▼ Richmond – RiSKy/LAyLO/JUT/P.T.S

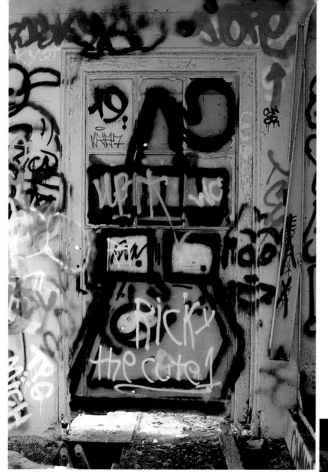

▲ Richmond – Ricky the cute 1
▼ Richmond – FLEA

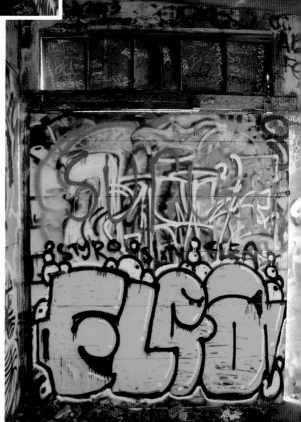

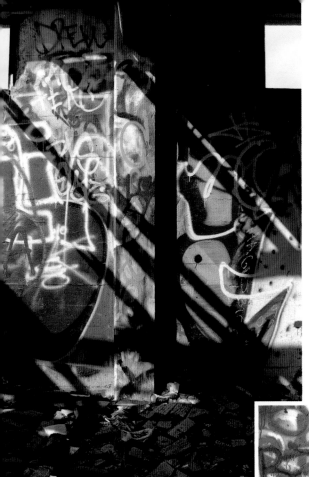

▲ Richmond – DREW
▼ Richmond – BaNDO/Layers Detail

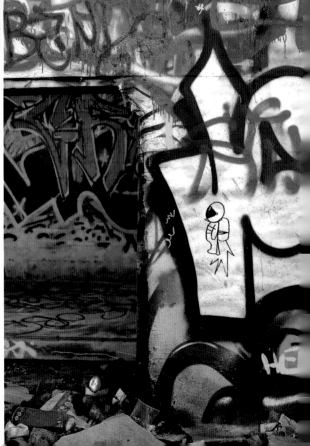

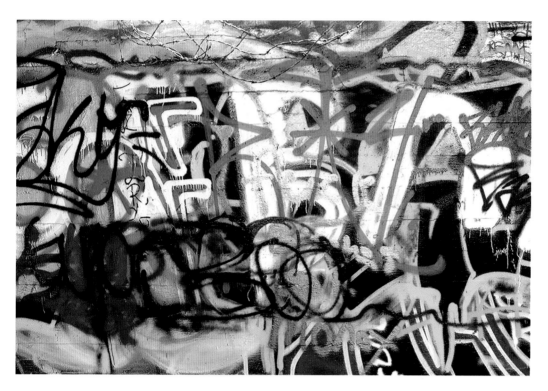

▲ Richmond – Barbed Wire
▼ Richmond – DeS

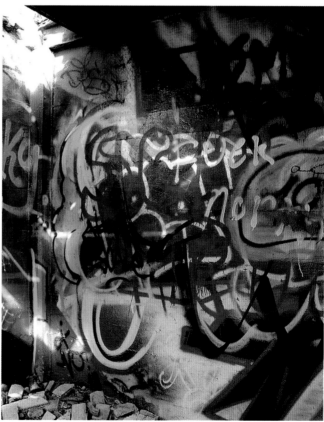

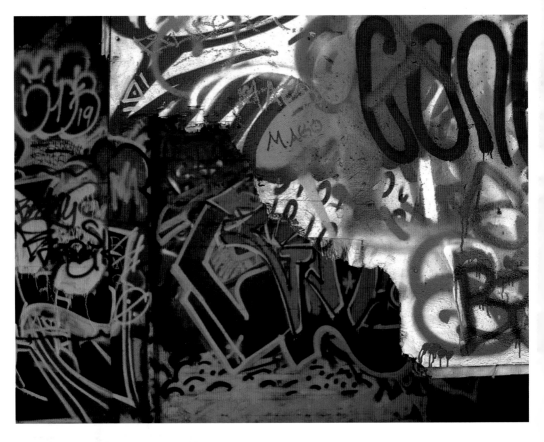

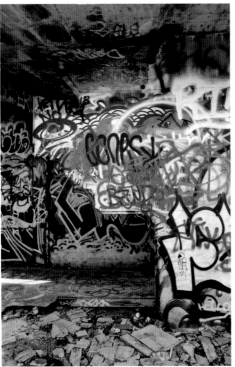

▲ Richmond – Layers
▼ Richmond – Layers detail/MAGO

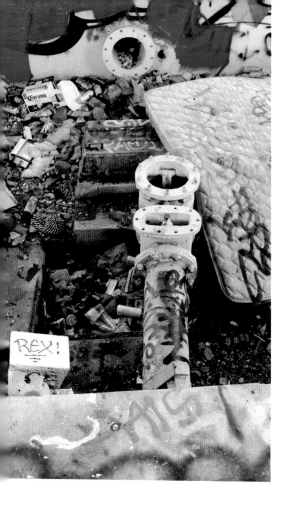

▲ Richmond – REX
▼ Richmond – RiSKy/BOX

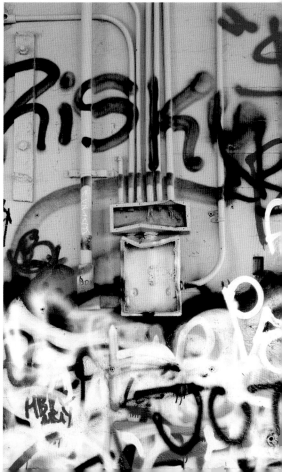

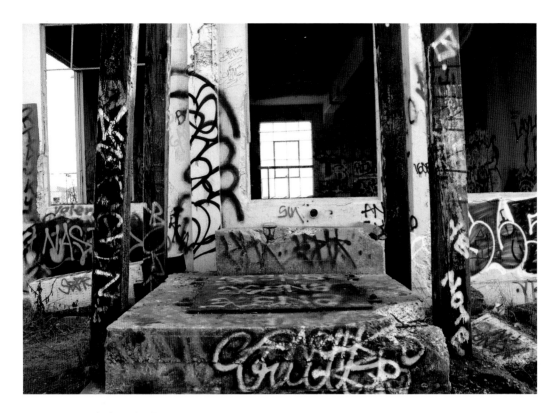

▲ Richmond – SIN/NOTE
▼ Richmond – NASTy

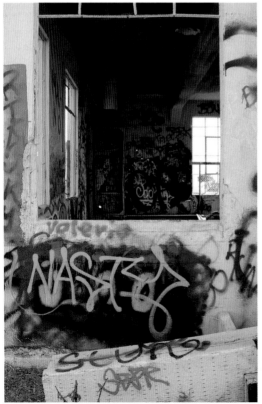

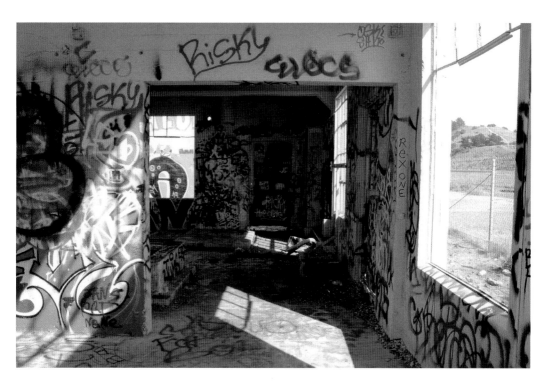

▲ Richmond – Risky/ReX ONE
▼ Richmond – HANDS CAN/LALO

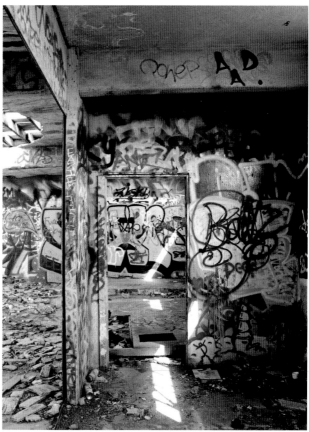

▲ Richmond – Study In Brown
▼ Richmond – Risky/NHB

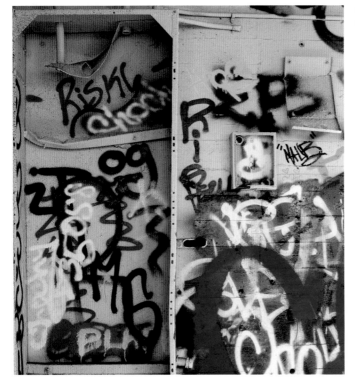

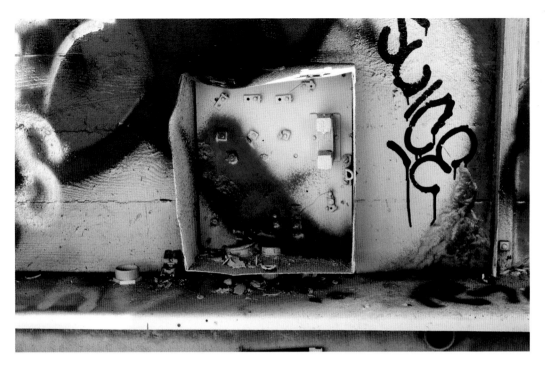

▲ Richmond – JUICE
▼ Richmond – BaNDO

GLOSSARY

BANKSY: "The mythical character of the graffiti scene, Banksy is identified as a troubadour of modern times. Renowned committed artist, no social fact resists him since he is incisive and mind-blowing in his art. Nowadays, Banksy has a place among the greats of this world by his countless reprehensible, but very subversive acts. He loves to provoke, shock even to disturb society and that is why his work is so important. Despite his ability to break the rules, he remains to this day a mystery since his true identity has never been revealed." (http://www.artbanksy.com)

BASQUIAT: "Jean-Michel Basquiat was born on December 22, 1960, in Brooklyn, New York. He first attracted attention for his graffiti under the name 'SAMO' in New York City. He sold sweatshirts and postcards featuring his artwork on the streets before his painting career took off. He collaborated with Andy Warhol in the mid-1980s, which resulted in a show of their work. Basquiat died on August 12, 1988, in New York City." (https://www.biography.com/artist/jean-michel-basquiat)

KEITH HARING: Keith Haring first became noticed when he began drawing on unused advertising panels in the New York subway. By the end of his career he was an internationally known artist who is still exhibited in museums today. (http://www.haring.com/!/about-haring/bio)

TAG: A stylized signature, normally done in one color. The simplest and most prevalent type of graffiti, a tag is often done in a color that contrasts sharply with its background. Tag can also be used as a verb meaning "to sign." Writers often tag on or beside their pieces, following the practice of traditional artists who sign their artwork.

BIBLIOGRAPHY

7x7, "A Perfect Day in Richmond: Hidden Wineries, Authentic Eats + Miles of Waterfront," https://www.7x7.com/perfect-day-in-richmond-california-2611754495.html?rebelltitem=1#rebelltitem1, 2018.

Berkleyside, "Berkeley's homeless population jumped 13% in two years.," https://www.berkeleyside.com/2019/07/23/berkeleys-homeless-population-jumped-13-in-past-two-years, 2019.

Bums' Paradise. Dir's. Tomas McCabe, Andrei Rozen. Writer Robert "Rabbit" Barringer. 2003. Movie.

East Bay Express, "A Decidedly Special Delivery," https://www.eastbayexpress.com/oakland/a-decidedly-special-delivery/Content?oid=3328962, 2012.

East Bay Express, "The Forces Driving Gentrification in Oakland," https://www.eastbayexpress.com/oakland/the-forces-driving-gentrification-in-oakland/Content?oid=20312733, 2018.

East Bay Express, 'The Graffiti Hunters," https://www.eastbayexpress.com/oakland/the-graffiti-hunters/Content?oid=3966284&showFullText=true, 2014.

Estately Blog, "21 Things You Should Know Before Moving To Alameda," https://www.estately.com/blog/2015/11/20-things-you-should-know-before-moving-to-alameda/, 2019.

Preservation Leadership Forum, "Art or Awful: The Conservation of Graffiti," https://forum.savingplaces.org/blogs/special-contributor/2019/05/30/art-or-awful-the-conservation-of-graffiti, 2019.

The Mercury News, "Oakland's homeless population grows 47 percent in two years," https://www.mercurynews.com/2019/07/23/oakland-saw-a-47-percent-spike-in-homelessness-this-year/, 2019

Where Do you Go When It Rains? Dir. Andy Kreamer. 2013. Video.

Wikipedia, "Albany Bulb," https://en.wikipedia.org/wiki/Albany_Bulb#targetText=The%20Bulb%20proper—the%20round,as%20is%20still%20very%20visible., 2019.

Wikipedia, "Graffiti,"https://en.wikipedia.org/wiki/Graffiti, 2019.

Wikipedia, "Glossary of Graffiti,"https://en.wikipedia.org/wiki/Glossary_of_graffiti, 2019.

Wikipedia, 'Oakland, CA', https://en.wikipedia.org/wiki/Oakland,_California, 2019.

Wikipedia, "University of California, Berkeley," https://en.wikipedia.org/wiki/University_of_California,_Berkeley, 2019.

World Population Review, "Berkeley, California, Population 2019," http://worldpopulationreview.com/us-cities/berkeley-ca-population, 2019.

World Population Review, "Oakland, California, Population 2019," http://worldpopulationreview.com/us-cities/oakland-population, 2019.

ABOUT THE AUTHOR

XAN BLOOD WALKER was born in Seattle, Washington, in the heat of summer. She learned print photography in high school, and went on to obtain two BFAs, one in printmaking and another in painting from the University of Washington. Many years later, when pursuing graduate studies in counseling, she obtained a Master's Certificate in Art Therapy.

Prior to her higher education, she attended the school of hard knocks in Seattle, San Francisco, and Los Angeles, as an 80s street punk at the height of the punk rock scene. With over thirty years in recovery, she finds a way to blend her varied experiences into a unique and personal style.

Currently she is branching out into two new areas: documenting the living breathing urban landscape through photojournalism and incorporating mixed media into her photography. She has already begun using graffiti marker, and hopes to add beeswax from her beehive, as well as dip back into her printmaking background with stenciling, lino block, and woodcutting.

ARTWORK

Xan has exhibited her work primarily in group shows in Seattle, San Francisco, Emeryville, Alameda, Oakland, Los Angeles, and New York.

Honors and Activities

Xan was awarded a Links Scholarship for her woodblock print depictions of her emotional experiences around trauma. She contributed as an intern artist for the mural project on the Women's Building in San Francisco, CA, in 1994.

Press

Studio Notes wrote an article about Xan in December of 1995, and she was honored to have a photo of hers used as the cover for the book *Representations of the Cuban and Philippine Insurrections on the Spanish Stage 1887-1898*, published in 2001 by D. J. O'Connor.